OLIVER'S
BIRDS

To Simon Weitzman
For his patience, creativity, friendship and care.

OLIVER'S BIRDS

Photographs by Oliver Hellowell

with Forewords by Iolo Williams and Ken Jenkins

ACC ART BOOKS

CONTENTS

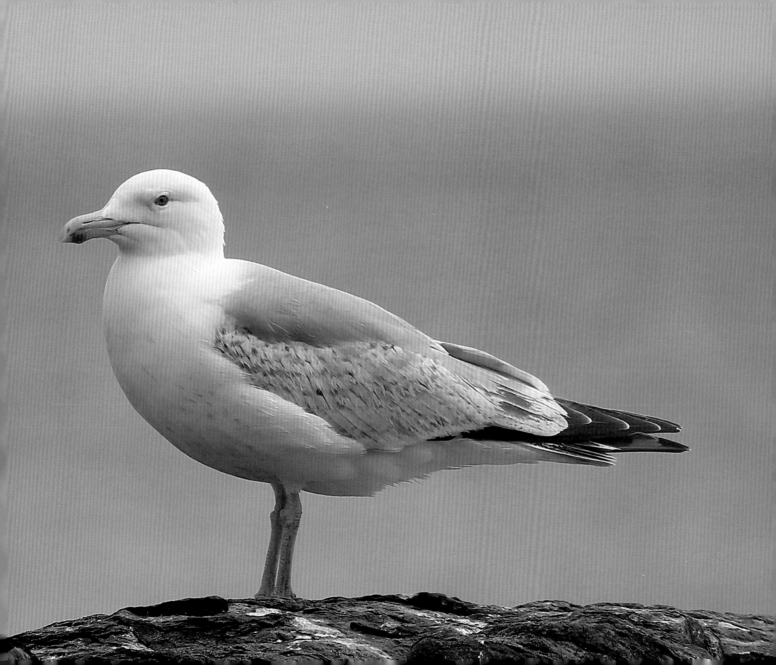

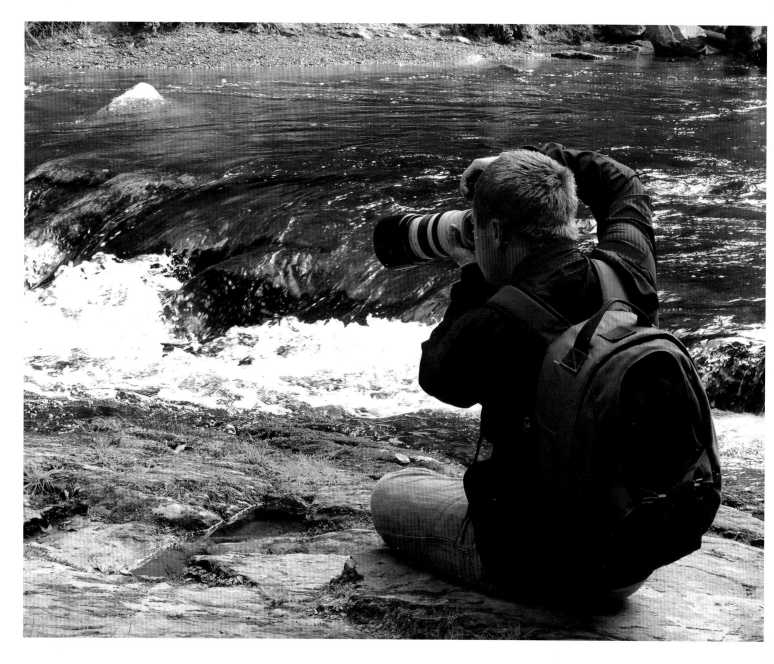

OLIVER HELLOWELL
PHOTOGRAPHER

Photography allows a person to communicate what they see and how they see it, in a way which does not require clever professional language or description, and which reaches out quite directly to the eye of the beholder.

How wonderful then, that a young man, for whom communication brings with it quite specific challenges, is able to use photography to interact with people all over our planet, thus showing them his own unique view of wildlife and the natural world around him which he so loves.

Oliver Hellowell, born in July 1996, is a young man fast achieving his dream of being a professional landscape and wildlife photographer.

Nothing too unusual about that you might think, until you realise that Oliver happens to have Down Syndrome.

As you might imagine, the journey travelled by this remarkable young man to get where he is today has certainly encountered challenges.

At 3 months old he had open heart surgery to repair three serious cardiac defects, after which his mother discovered that medics had feared he would not survive long enough to reach surgery. By the time he was 3 years old, predictions by speech and language therapists and physiotherapists had pronounced him so severely delayed and affected by his Down Syndrome and additional diagnoses, that it was believed he would never be able to produce speech which could be

understood by an unfamiliar listener. It was also thought that his extremely poor muscle tone would leave him unable to manage much physical activity of any kind and that taking part in 'sports' would be beyond him.

However, with his determined and optimistic mother, Wendy, always at his side and with encouragement from his elder sister, Anna, Oliver grew up enjoying skateboarding, football, basketball, snooker and golf and became a happy, healthy and fit young man. At the age of 11 he became fascinated by photography and with the patient mentoring and instruction provided by his stepfather, Mike, who came into Oliver's life when he was nearly ten years old, Oliver learned and was able to freely develop his own unique style and view of the world through his camera. His live interviews on both radio and television have put predictions to shame, and his appearances on the BBC's *The One Show* brought him further into the public eye, raising positive awareness and encouraging so many other parents and families. With professionals having predicted a particularly unfortunate and bleak life for this young man, his family take particular delight in the fact that he has completely smashed all those predictions, and that photography has helped him to do that.

Wildlife has been a fascination for Oliver ever since he was a small child who was glued to the screen every time his hero David Attenborough appeared with the amazing bird and animal life to be found across the globe. He has always loved the great outdoors with frequent visits to zoos and parks etc. and used to ask "Can we go to the wild?!" when he wanted to go off exploring the countryside. Birds are his particular favourite and he retains a quite fantastic bank of knowledge on the subject, being able to identify hundreds of species at a glance.

Oliver's vision is slightly different to yours and mine in a way which is best described as his having significantly reduced contrast. The physical

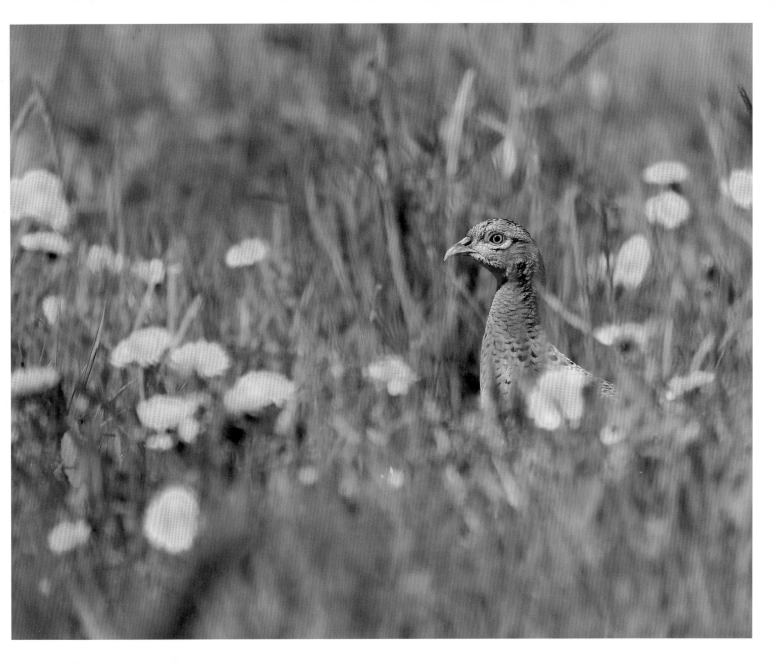

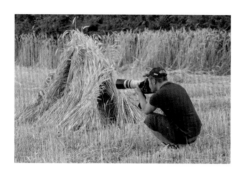

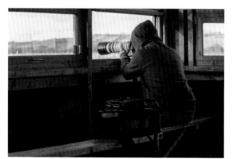

makeup of the eyes of people who have Down Syndrome is slightly irregular and causes their vision to appear almost as if they are looking through a fine mist or fog. This is no doubt one of the reasons why Oliver loves to boost the contrast of his pictures in Photoshop, encouraging the colours to leap out and have more clarity for him.

Oliver has an innate talent for framing and composition and certainly has his own style, frequently capturing 'parts' of the animal or bird he is focussing on rather than seeking to seize an image of the 'whole'. He also enjoys adopting an unusual angle. He can find some situations and environments overwhelming and a camera allows him to filter out the rest and concentrate on just the piece he's interested in. He constantly refers to the rear screen, checking after almost every click of the shutter, to see if he has caught exactly the image he intended.

At home in the Blackdown Hills of Somerset, where he lives with his family, Oliver is fortunate enough to have a very large back garden area with a purpose-built hide as well as temporary mobile hides, which assist with the build up of his massive image collection of native birdlife. Being a booklover, he owns more than 300 books, with around 40 of those being bird books.

On Facebook Oliver has a following of over 65,000 fans, drawn from across the globe, while his website receives orders every week from literally all over the world. He enjoys a full, interesting and busy life; he has a loving family, and makes friends wherever he goes.

In 2015 Oliver appeared on the BBC's *The One Show* for the first time and won the National Diversity Award in the category of National Role Model for Disability.

In 2017 Tennessee Tourism commissioned Oliver to capture the Smoky Mountains National Park in his own inimitable style. They cleverly thought to introduce him to Ken Jenkins, a professional photographer and gallery owner, who had lived and grown up in the Smoky Mountains. Oliver and Ken bonded instantly over a bacon breakfast and talking about their mutual passion – birds. By the end of the couple of days they spent together, the two had forged a deep and abiding friendship which continues to span the ocean between them, the pair having already met up and enjoyed a joint exhibition in London Heathrow's T5 Gallery.

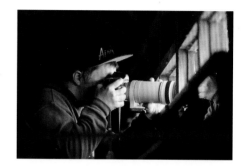

This is a young man who has been surrounded by love, optimism, and encouragement, and who has used photography to get him from
predictions that he would never get anywhere,
to become a professional,
whose images are going
EVERYWHERE.

Wendy O'Carroll
(Oliver's mum)

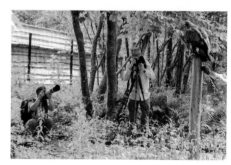

The following acronyms are used to identify some of the sites where Oliver has photographed birds of prey:

ICBP – The International Centre for Birds of Prey
in Newent, Gloucestershire.

LLBOPC – The Loch Lomond Bird of Prey Centre,
near Balloch, Scotland.

AEF – The American Eagle Foundation
outside Pigeon Forge in Tennessee, USA.

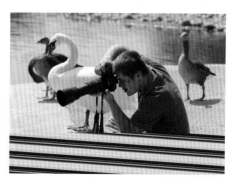

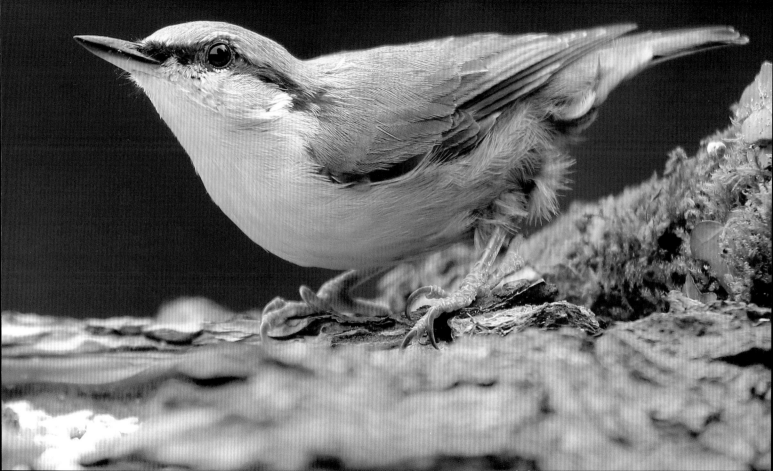

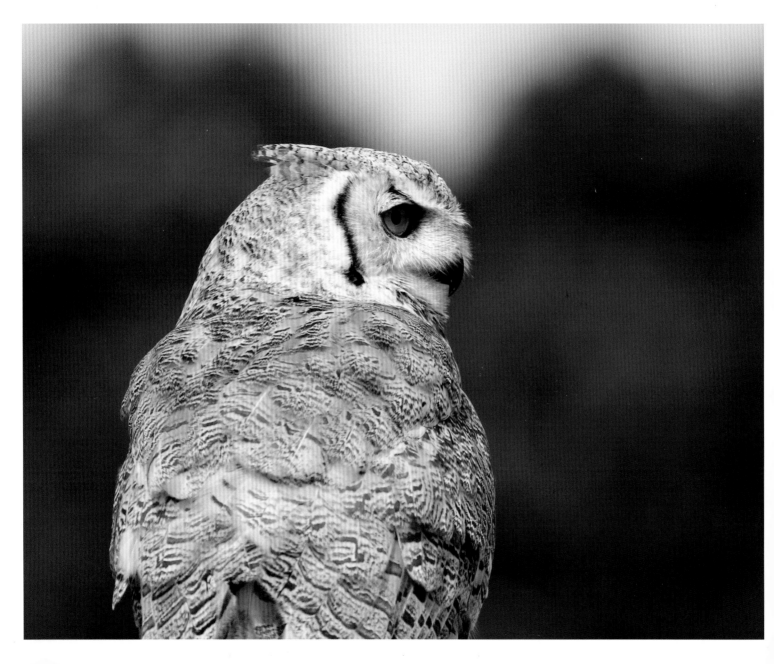

NOTE from KEN JENKINS

To look closely at a photograph taken by Oliver Hellowell is a study in the miraculous. From the hour that I met Ollie, I was convinced that I was in the presence of an amazing young man who never looks back and sees no limitations. Within hours, Ollie and I became best friends, mainly because our hearts connected through a bond of simplicity and a lack of pretenses. We walked through mountain valleys in America and have since recorded birds of prey as well as the lovely hills of Scotland.

Ollie has an attachment to the most difficult subject in nature photography, and that is the capturing of bird behavior. We share that love through books, the images of others, and our own pursuit. I see his eye and, moreover, his passion for the feathered world. He just lights up in the presence of a bird song, waiting patiently for a fleeting glimpse which he records 'his way'.

As you turn the pages of this wonderful piece of work, you will accompany a young man who has accomplished what few are able to do. Ollie presents to his viewers a heart-felt representation, without distraction, of his attachment to what is often referred to as the most intricate of all creatures. He puts forth his effort uniquely, refusing to be influenced by anything other that the gift within him and the heart that drives him.

You will surely feel that you know Ollie personally after spending time with his photography. It is such a personal offering that stands alone as a work of art from one who could be described by the skeptic as 'least likely'. But that limited viewpoint would be in error and would miss the kind, simple, willing, unpretentious offering of an individual that I have come to love for who he is as well as what he does.

Ken Jenkins, writer/photographer
Gatlinburg, Tennessee, USA

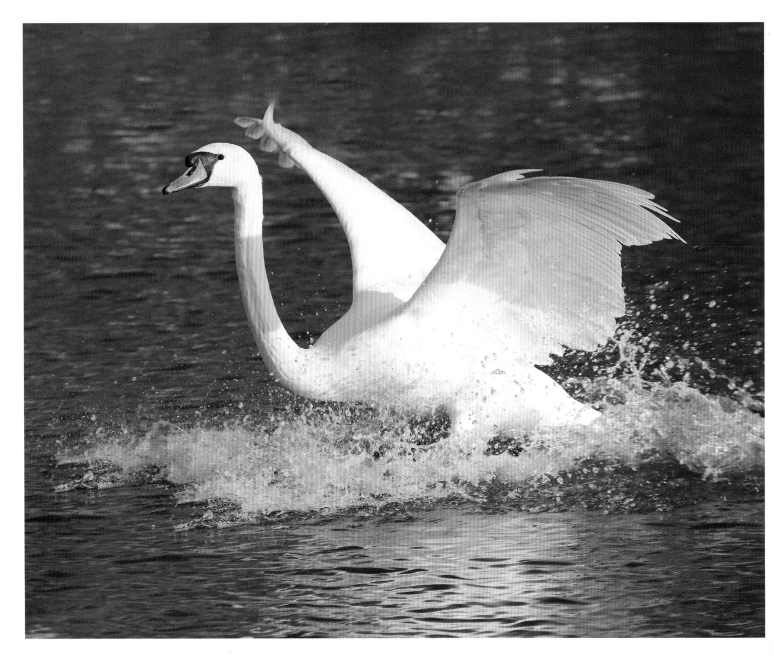

NOTE from IOLO WILLIAMS

Oliver Hellowell is a remarkable young man. I first met him many years ago at Slimbridge when he'd come up to meet one of his great heroes, Chris Packham, on the set of *Autumnwatch*. Little did I know that that fleeting encounter would become a lifelong friendship.

Ollie is a photographer, and an excellent one at that. He has an eye for a photograph like no-one else I know. I have accompanied him to various reserves around his home and watched him point and click his camera at what I believed to be bland, boring subjects. In Ollie's hands, however, the camera is more than a mere instrument, it is an extension of his inquisitive mind and every 'dull' photograph turned out to be an exquisite portrayal of the natural world. This book is testament to Ollie's ability as a photographer. Every photograph jumps out of the page, an explosion of colour and detail.

However, Oliver is so much more than just a photographer. He is a very competent birdwatcher, a funny raconteur, excellent company and a genuinely lovely young man. He has promised me that when he gets his own TV series (which he will), he will take me to a beach in the Bahamas to sip cold beers and eat bacon butties, and rest assured that I will hold him to that!

Ollie's photographs are sold throughout the world and his many TV appearances have made him a household name across much of the UK and beyond. His fame has not changed him one iota and I'm pleased to say that he is still exactly the same inquisitive 15 year old I met at Slimbridge all those years ago. Please buy this book, support a talented young photographer, and introduce a bit of 'Ollie' into all your lives.

Iolo Williams, naturalist, TV presenter, conservationist, writer and tour guide.

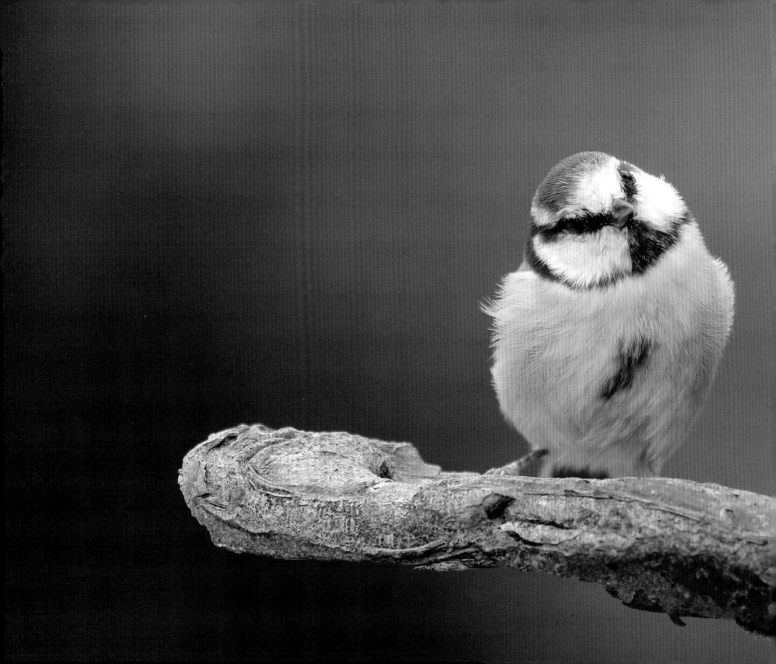

OLIVER'S FAVOURITES

As the title suggests, the following images are some of Oliver's favourite shots. This might be because of the bird he's captured on camera, or due to a particular aspect of the photograph, such as the crisp water droplets or ruffled feathers. Oliver explains his choices in his own words.

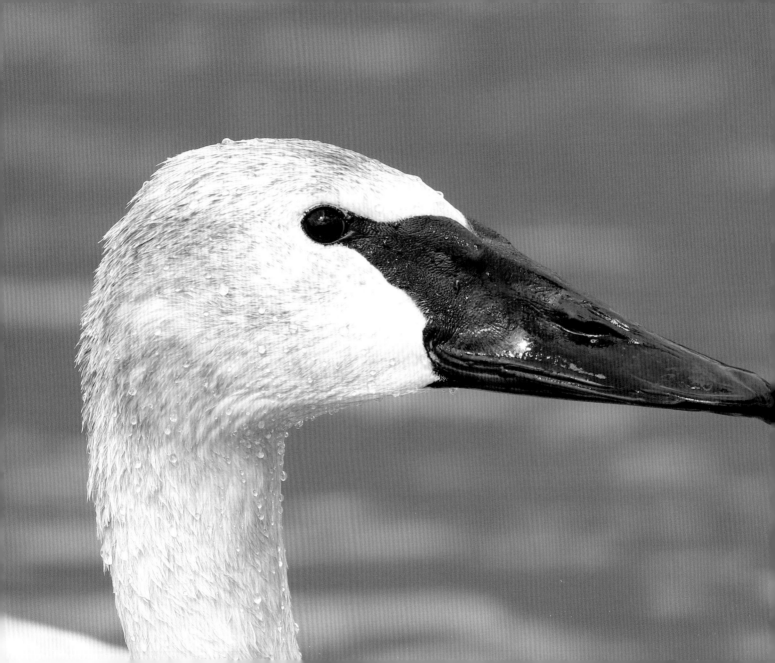

BEWICK'S SWAN
Slimbridge

Left: I went to Slimbridge and I saw one juvenile Bewick's swan. Their beaks are longer than the Mute swan. I got all the water droplets sharp.

Right: I like this picture because I like the framing and composition. I like that the Bewick's swan in front is in focus and the one behind is out of focus – and they both have their beaks down in their feathers, preening. It's a cool picture.

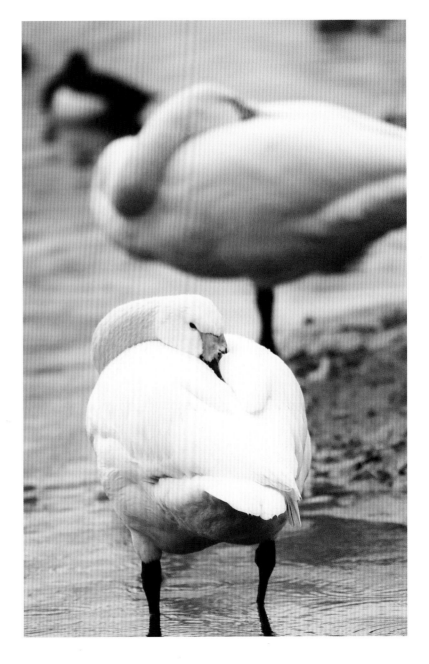

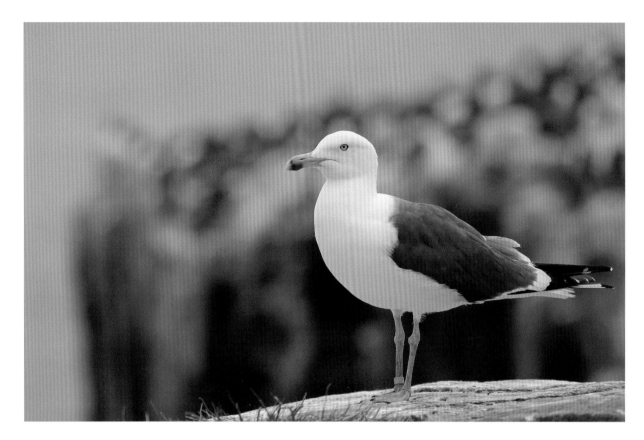

LESSER BLACK-BACKED GULL
Farne Islands, Northumberland

Most people don't like gulls very much, but I think they're amazing.

SHAG
Farne Islands, Northumberland

I hadn't ever seen a shag close up before; I found it on a nest when we walked around on the Farne Islands. I think it's beautiful. If you look closely at it around the eye, we think it looks amazing and a bit like a dinosaur.

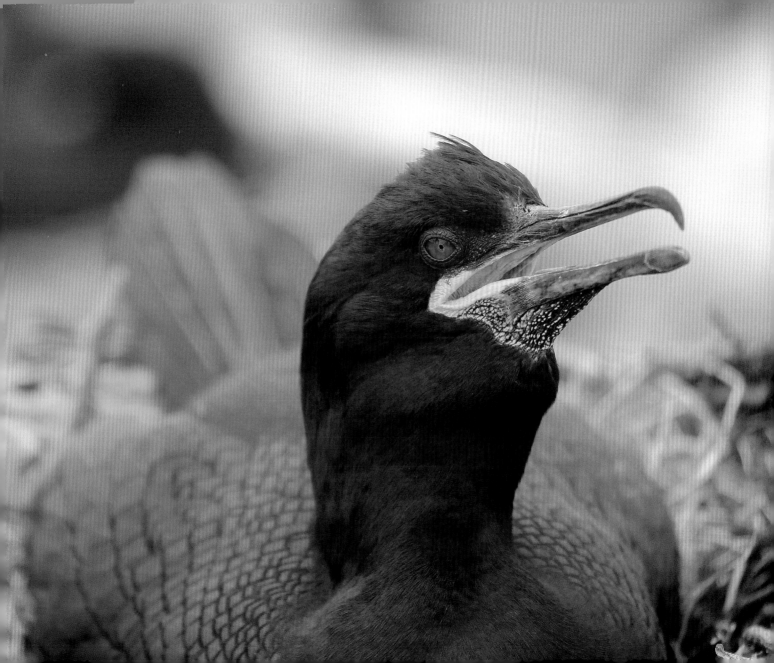

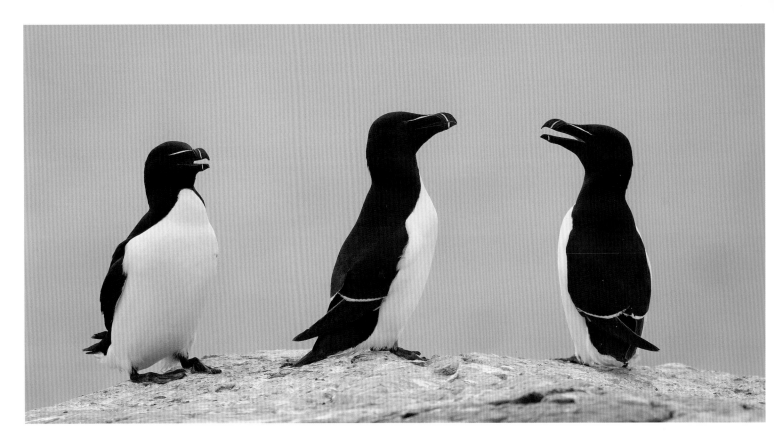

RAZORBILL
Farne Islands, Northumberland

I like this picture because it looks like the three razorbills are talking to each other and having an argument!

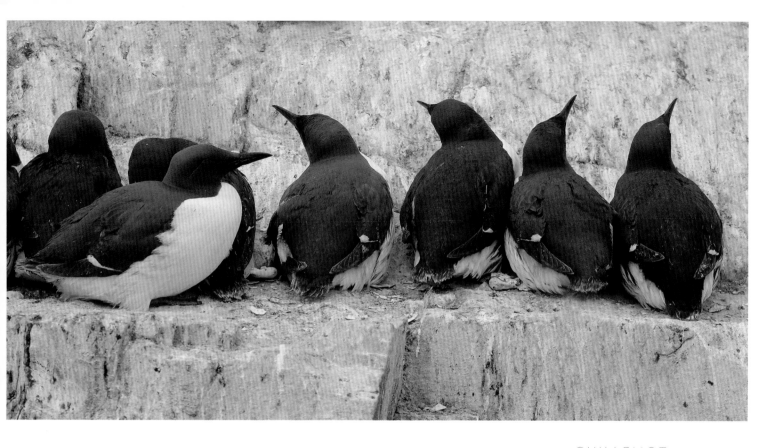

GUILLEMOT
Farne Islands, Northumberland

I saw these guillemots on a cliff on the Farne Islands – I was on a little boat. There were thousands of guillemots on the rocks, and I liked these because they were in a row.

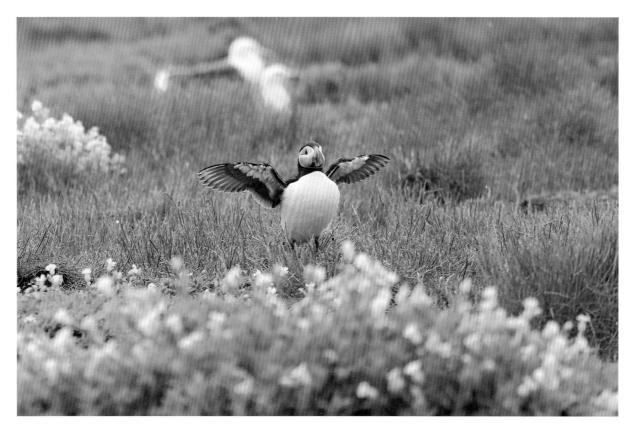

PUFFIN

Farne Islands, Northumberland

Above: I was pleased to get this shot with the wings open. I really like this one. He's saying 'Look at me!'

Right: For some reason this puffin reminds me of my cat – and I love my cat!

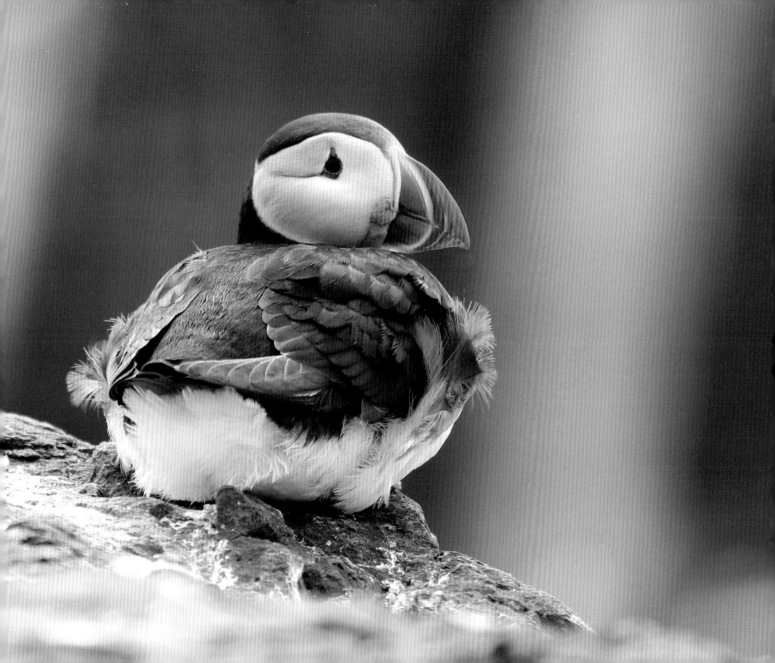

"I always wanted to see a great grey owl in Alaska, but I saw this one in Gloucestershire!"

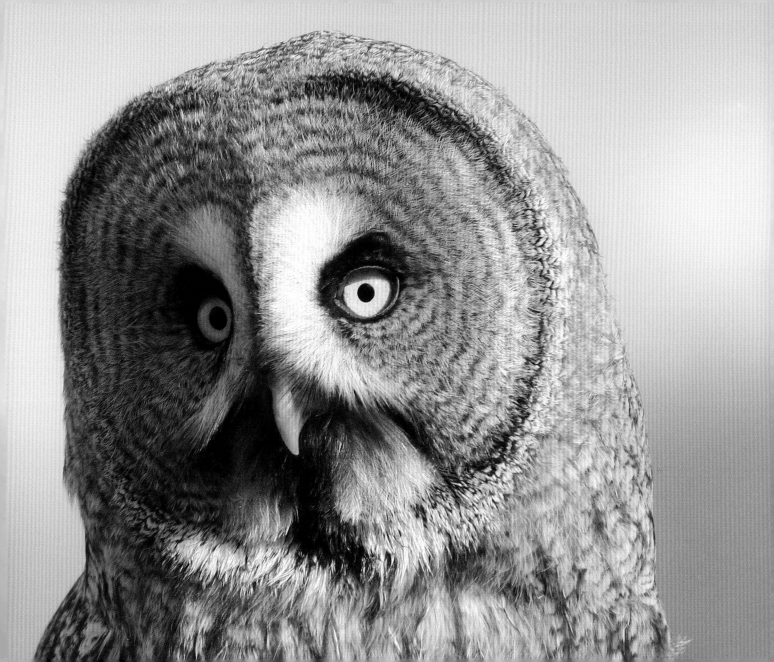

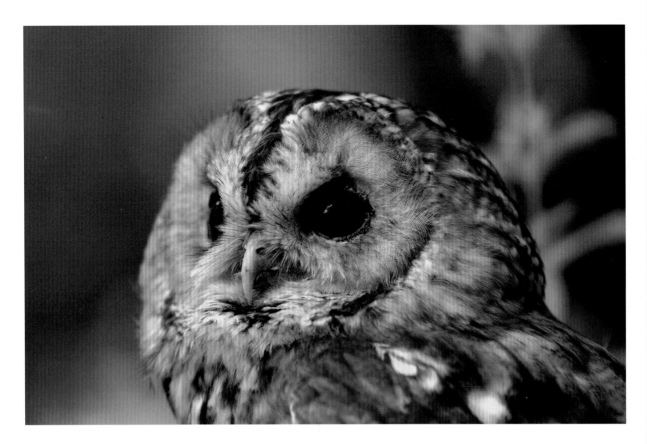

TAWNY OWL
LLBPC

At the Loch Lomond Bird of Prey Centre, Stewart let me hold Bernie on my arm with the special glove. It was special to me. I really liked Bernie, he was a lovely Owl.

HARRIS'S HAWK
Domino, ICBP

I like its hunting skills and they feed on small mammals. It was cool to see one in real life.

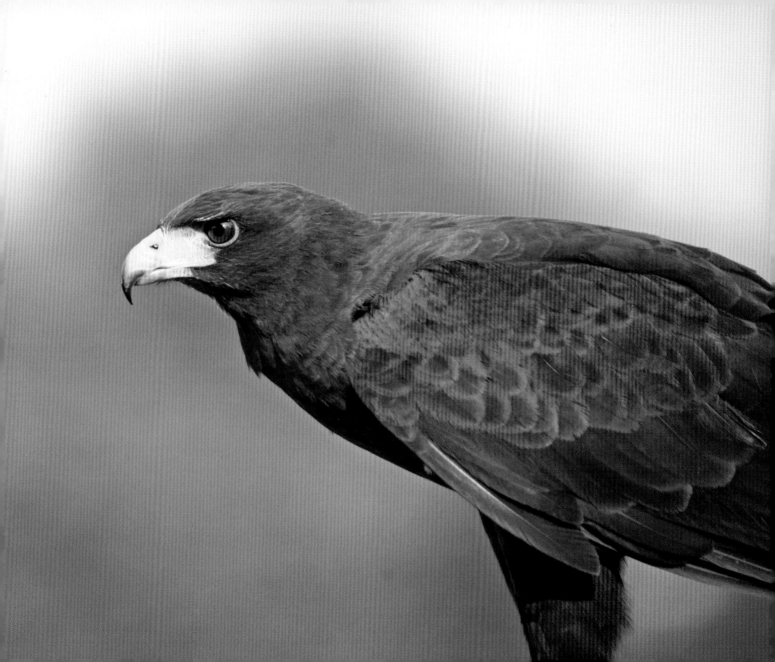

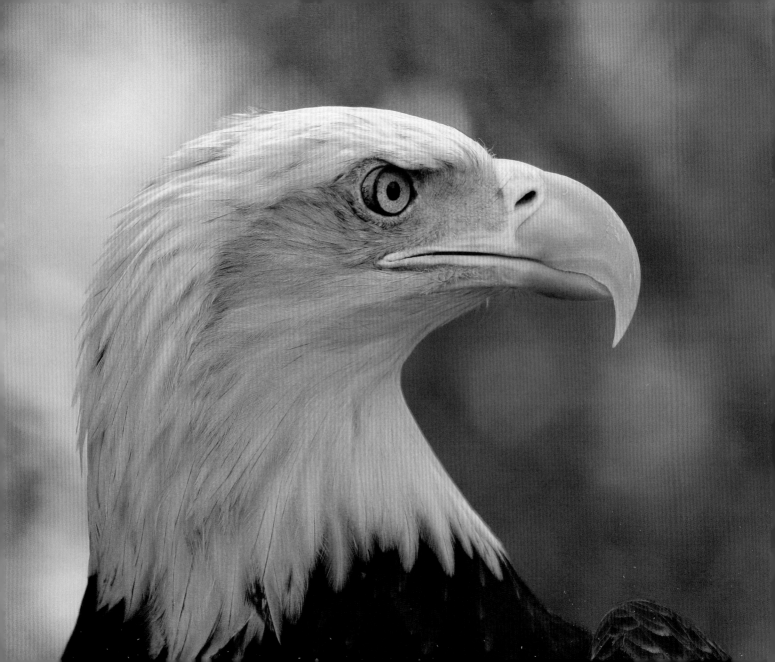

BALD EAGLE
Majesty, AEF

I like bald eagles, they are really big birds. I took this in America. This picture is so amazing – you can even see the veins in the eagle's eye!

GOSHAWK
Jess, LLBOPC

I went to Scotland with my best mate, Ken Jenkins from Tennessee, to do some filming. We went to the Loch Lomond Bird of Prey Centre and Stewart Robertson told us all about the birds. I got this fabulous close-up of the head of the goshawk – I'm really pleased with it.

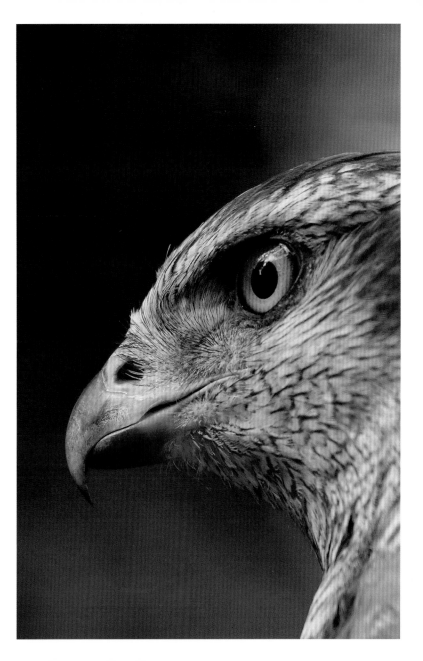

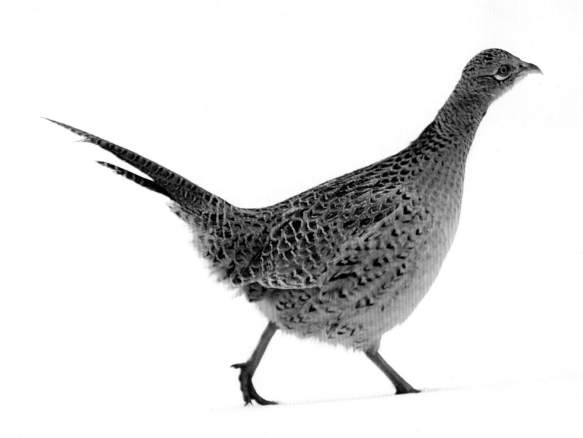

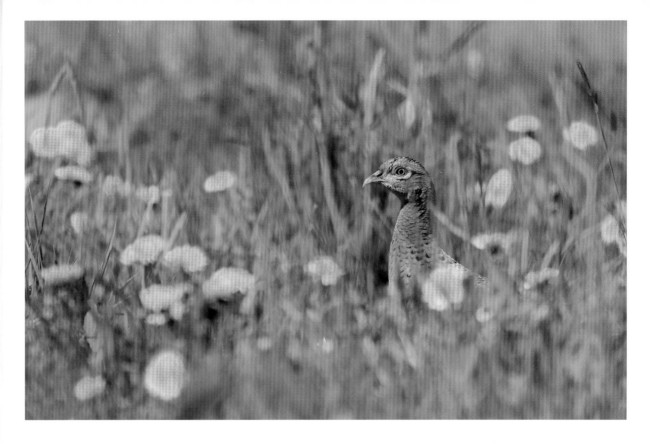

PHEASANT
Blackdown Hills, Somerset

Left: This is a female pheasant in our back garden when we had all the snow – my Dad was jealous of this shot!

Above: I was pleased to get this one – I like the flowers and I like the pheasant too – and I got the eye crisp in amongst the grass and the dandelions. We've got a bit of a meadow area in our big back garden and I waited to get the bird in the flowers.

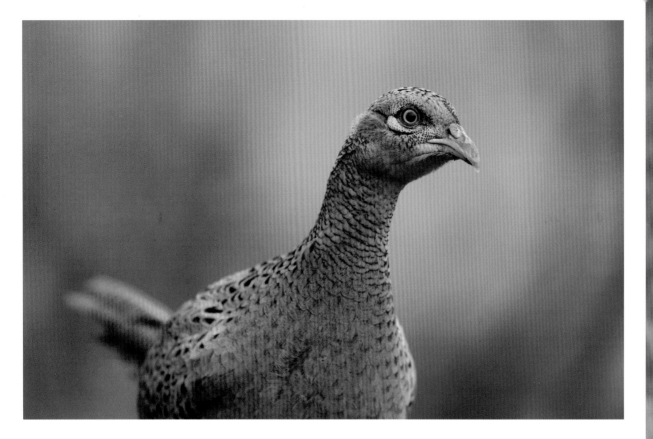

PHEASANT
Blackdown Hills, Somerset

Above: I like the eye in this picture and the beak. And the colours are vibrant. Most people think the female pheasant is boring and it's only the male that is beautiful, but look here and you can see all the colours she has!

Right: I think he's so beautiful; I like the head and the size of the bird and the amazing shiny colours. It's a striking bird.

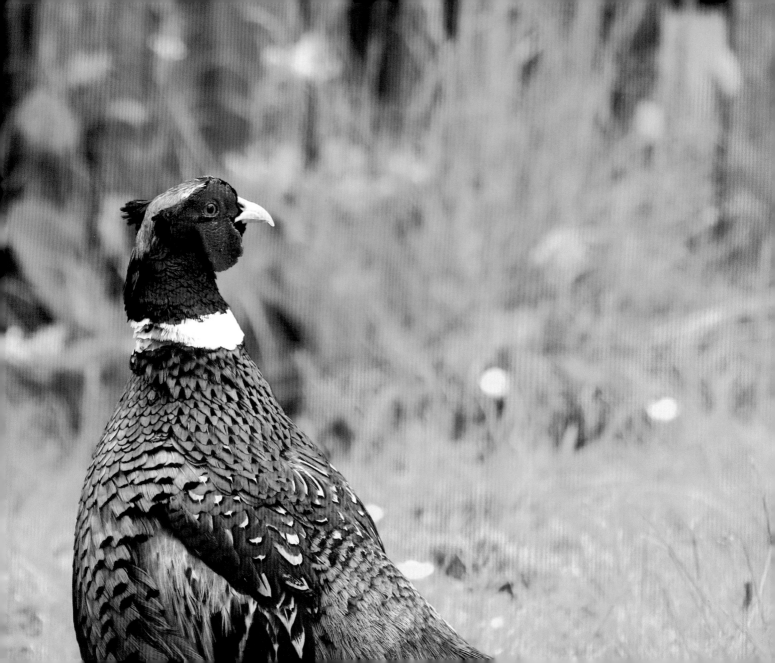

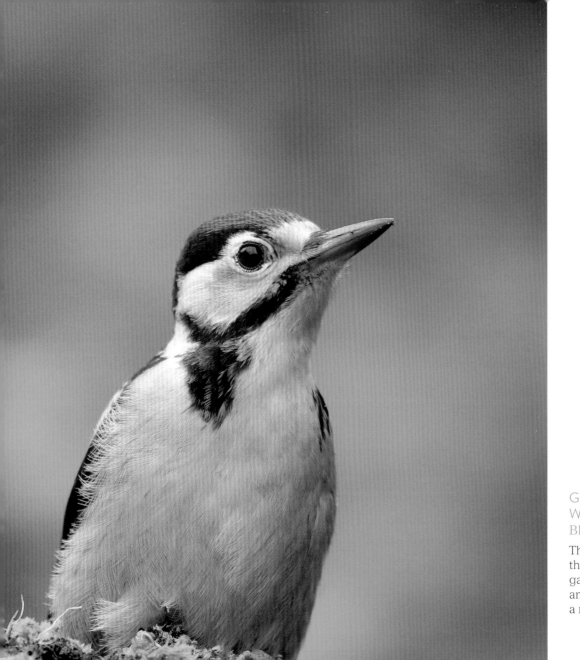

GREAT SPOTTED WOODPECKER
Blackdown Hills, Somerset

This is a juvenile woodpecker that I found from my hide in the garden. My mum is a redhead and the juvenile woodpecker is a redhead as well!

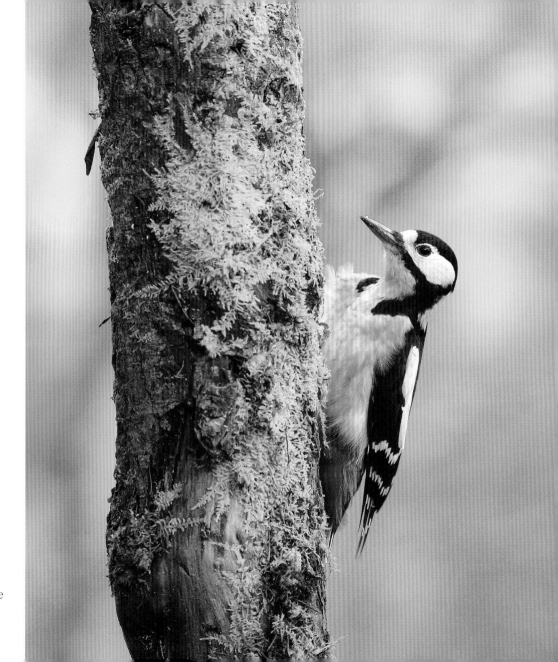

Woodpeckers are one of my favourite birds – they are striking too. They do like peanuts and peanut butter! You can use that to get them to come into your garden.

JAY
Teifi Marshes

I got this on holiday in Wales near the Teifi Marshes. When they fly you can see the flash of blue.

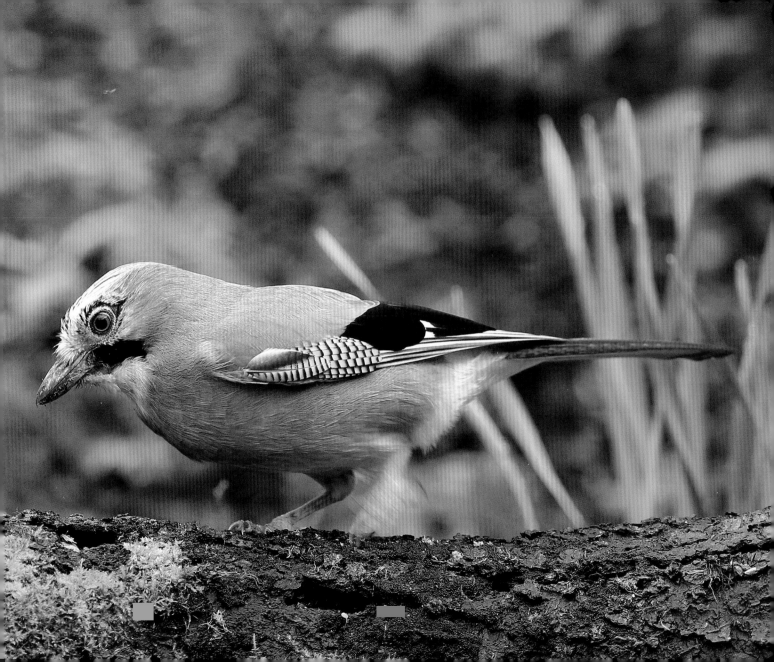

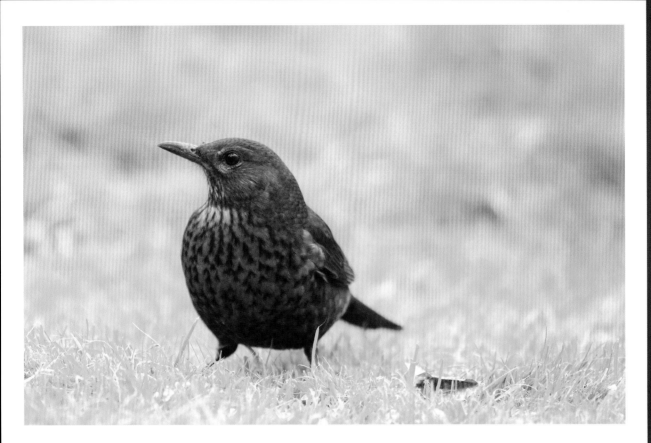

BLACKBIRD
Blackdown Hills, Somerset

Blackbirds are very common and most people don't take any notice of them, but they're one of my favourite birds.

BLUE TIT
Blackdown Hills, Somerset

This blue tit is a stunning picture. Look how blue his legs are – people don't notice that!

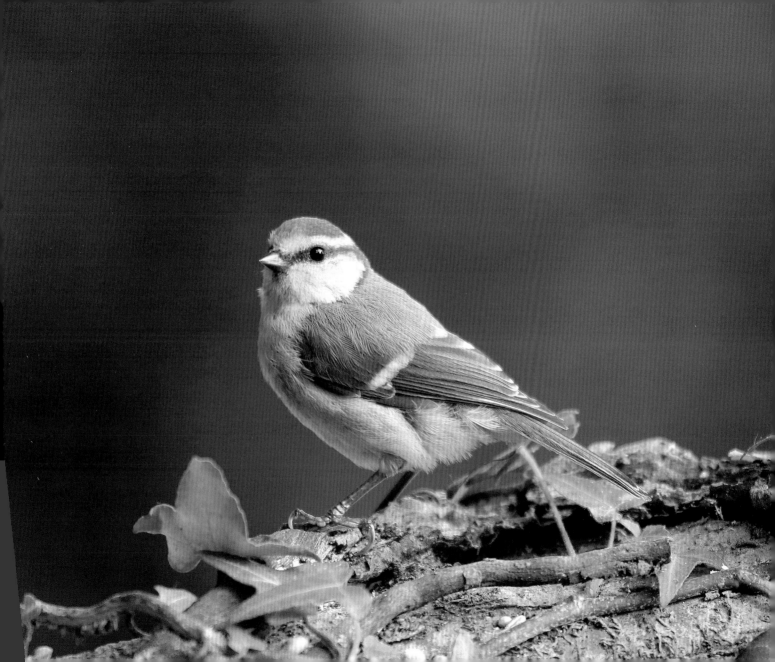

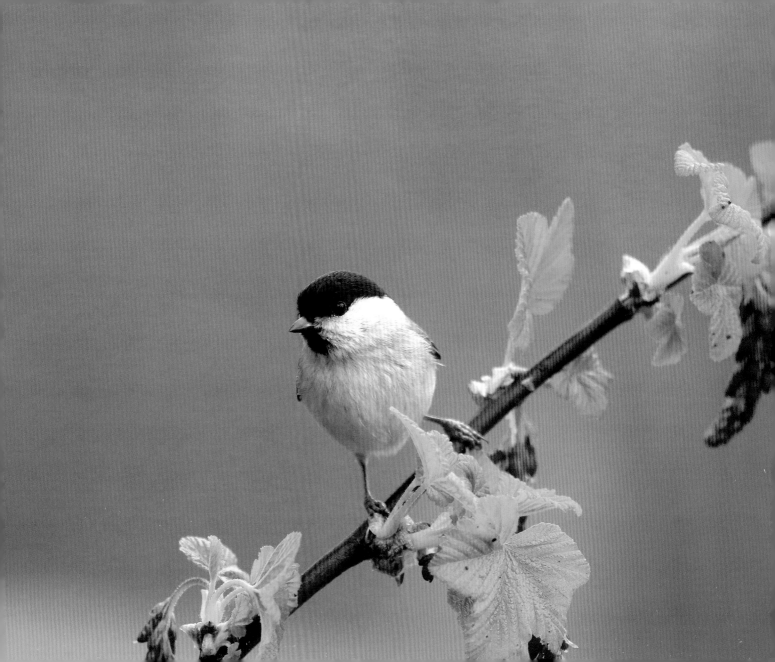

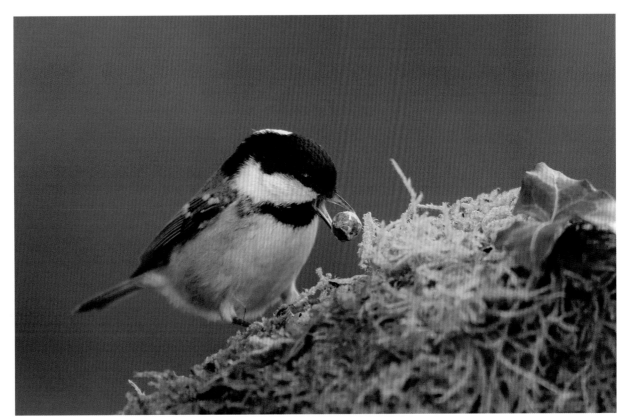

MARSH TIT
Blackdown Hills, Somerset

I like the colours of this picture
– they are vibrant. I like the little
bird and the colourful flowers
together. Marsh tits and willow
tits are really difficult to tell
apart!

COAL TIT
Blackdown Hills, Somerset

I like coal tits and that they are
so little. I really like pictures
where the bird has got food in
its beak; I take lots of those!

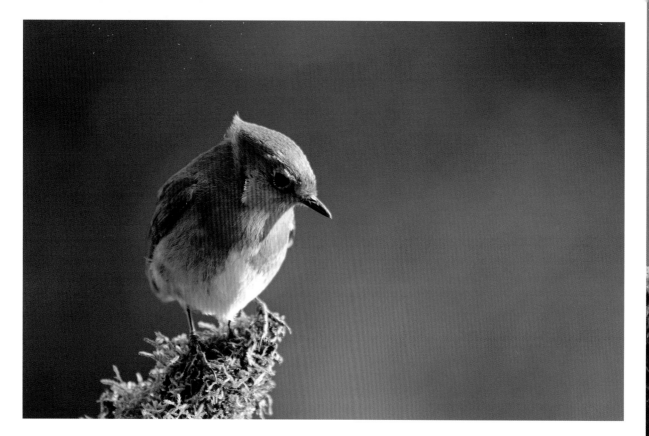

ROBIN
Blackdown Hills, Somerset

When the wind ruffles up the feathers on the birds, I really like it. It looks a bit different, and he was perched right on the top of the branch.

I got this in my back garden. I like robins, they're one of my favourite birds. We go out to the woods and get nice mossy logs for the birds to land on. I got this next to our reflection pool – but I didn't get the reflection!

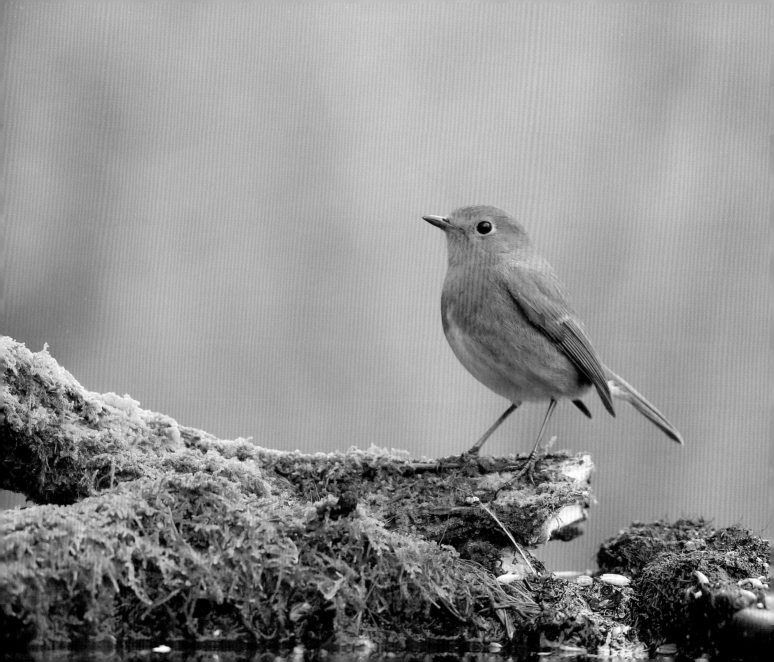

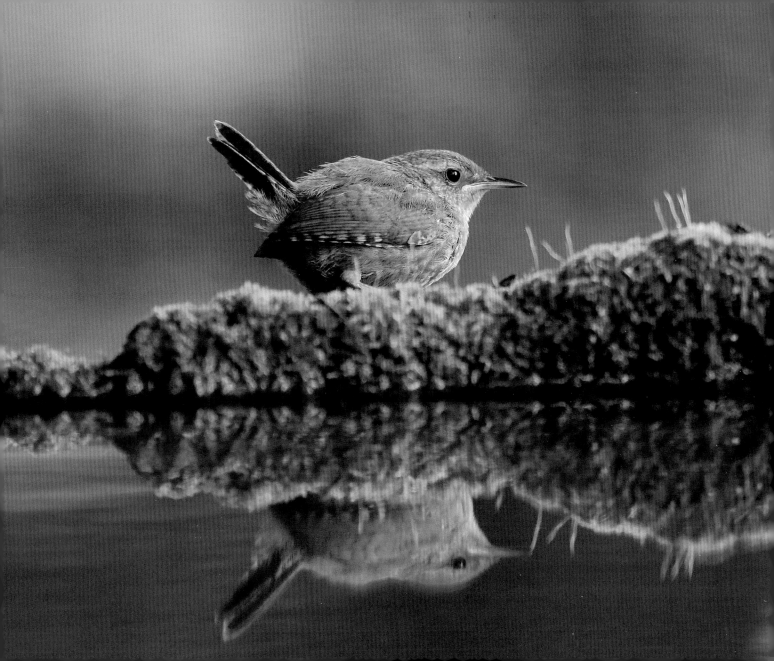

"Cracking birds, wrens! I like wrens! I gave a print of this picture to my mate Iolo Williams because he likes wrens too."

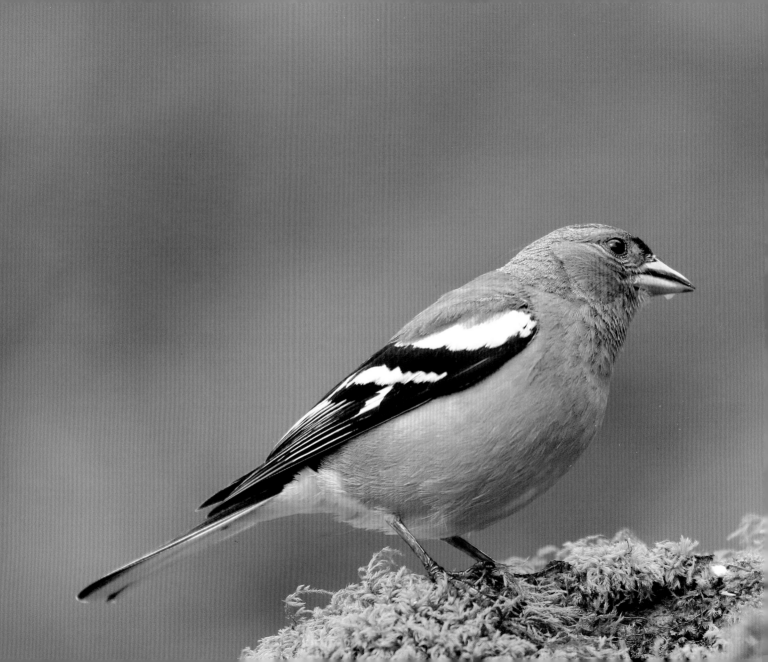

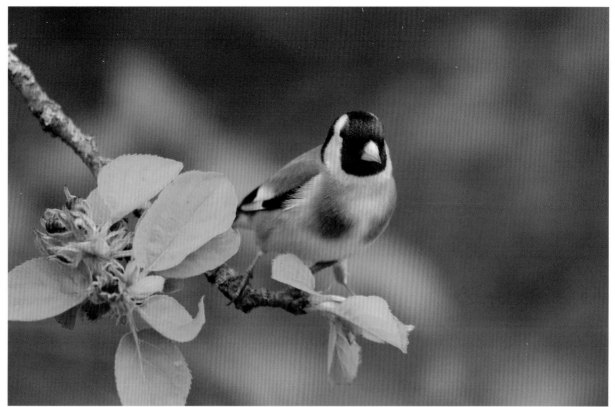

CHAFFINCH
Blackdown Hills, Somerset

I like chaffinches because they're so colourful. I would really like to get a photo of a bullfinch, but I haven't got one yet!

GOLDFINCH
Blackdown Hills, Somerset

I like goldfinches because they are multicoloured. I took this picture at home in our big apple tree. We made a big box stand out of pallets and stood our tent hide on top so we could get the pictures right in the tree.

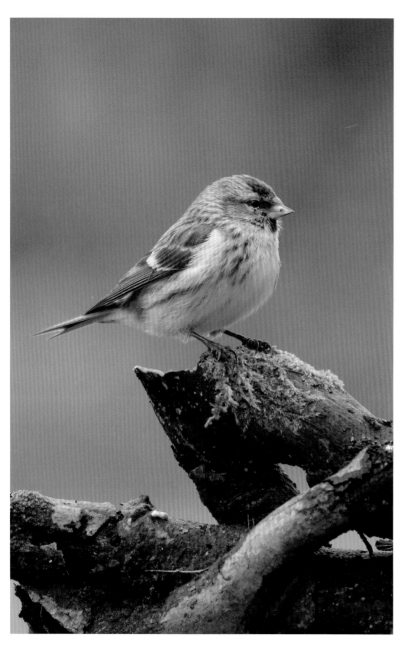

REDPOLL
Blackdown Hills, Somerset

2018 was the first year we had redpolls in the garden – one day we counted 33 in the front garden! I got my first ever redpoll pictures and I was really proud of them.

REED BUNTING
Greylake RSPB Reserve, Somerset

Out on the Somerset Levels at Greylake RSPB Reserve, I saw this bird.

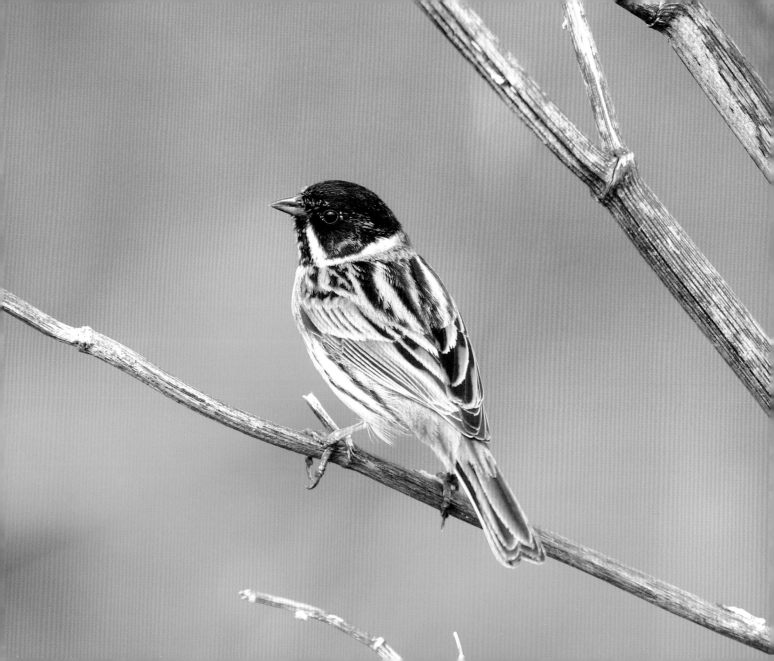

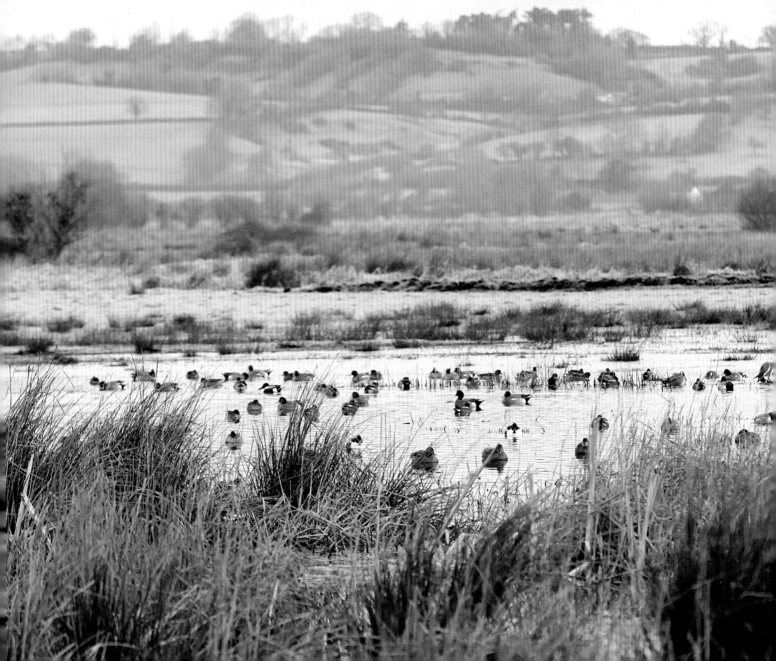

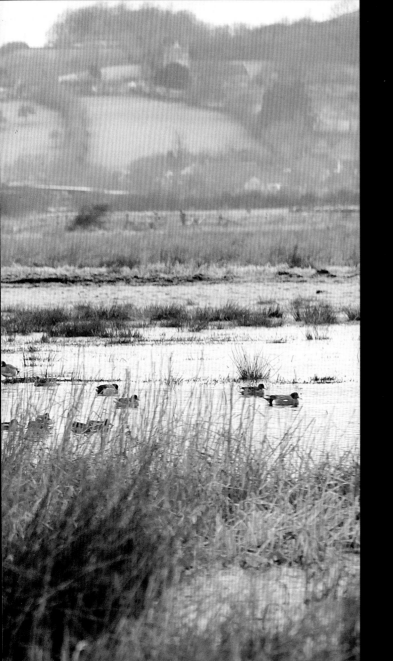

OUT ON THE LEVELS and INLAND WATER BIRDS

Although now living in the Blackdown Hills on the Somerset/Devon border, Oliver used to live out on the Somerset Levels. Greylake and Ham Wall RSPB Reserves are two places often frequented, and Oliver has been known to capture a great shot whilst sitting in the back seat of the car, in the car park, his camera resting on his open window, and well-equipped with a flask of hot chocolate and a bacon sandwich.

Slimbridge Wetland Centre is also a favourite haunt all the year round, where Oliver can once again enjoy getting close to the birds. He is very comfortable and confident sitting on the ground right in amongst the swans, and also has a particular fondness for flamingos.

His fascination with water means that water birds offer double the enjoyment from an image capturing point of view and many photos include water droplets and splashes.

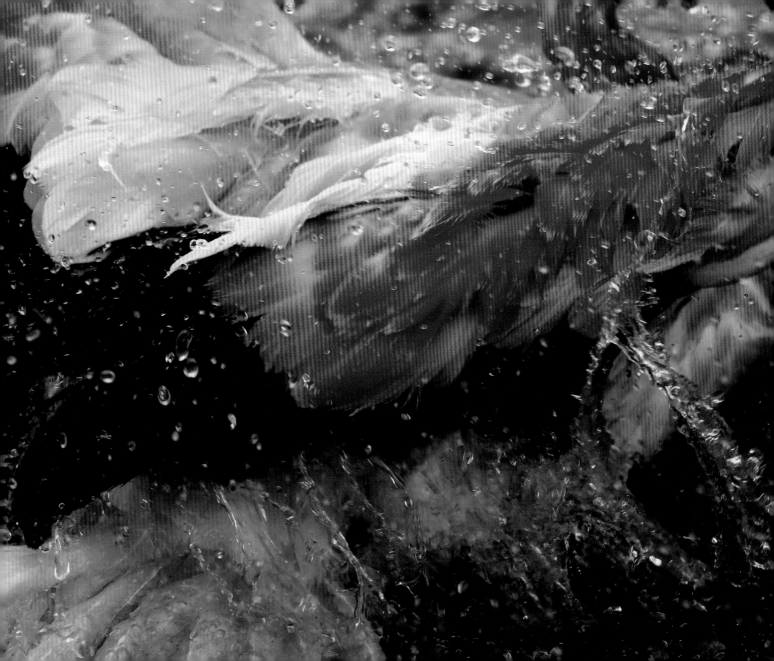

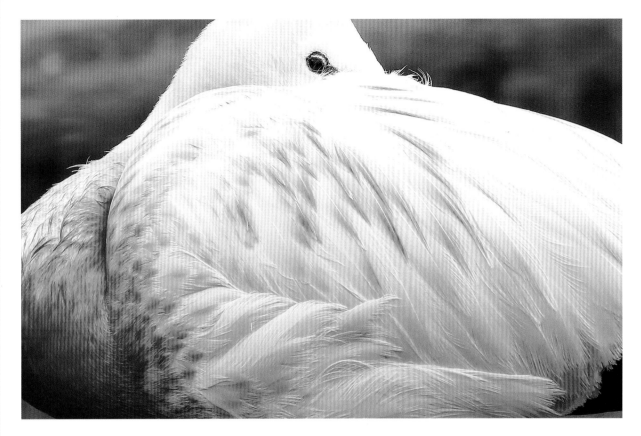

ANDEAN FLAMINGO
Slimbridge

Left: 'Flamenco Splashes'

Above: 'Peeping Tom'

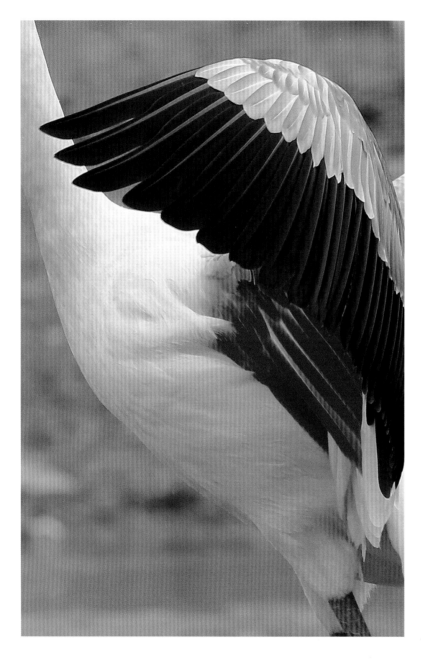

GREATER FLAMINGO
Slimbridge

Left: 'Wing Feathers'

Often focussed on the fabulous plumage of so many birds, it's common for Oliver's images to show only wings or feathers and no head at all!

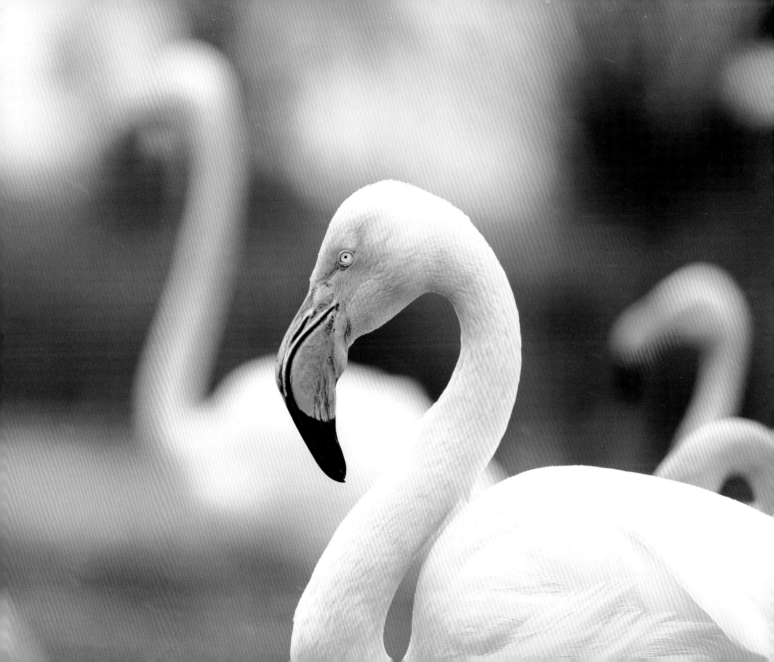

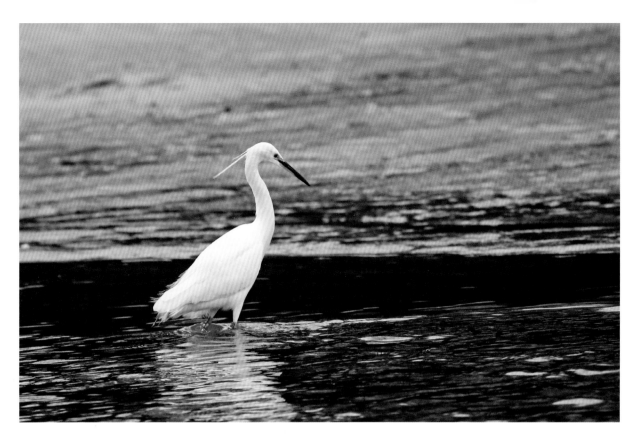

LITTLE EGRET
Kingsbridge, Devon

GREY HERON and
GREAT WHITE EGRET
Ham Wall RSPB Reserve,
Somerset

'Long Necks in the Reeds'

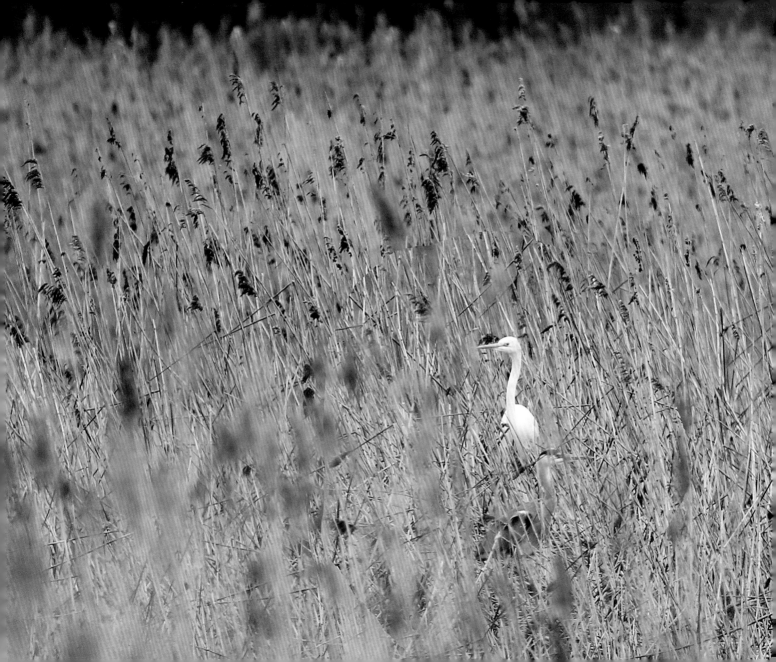

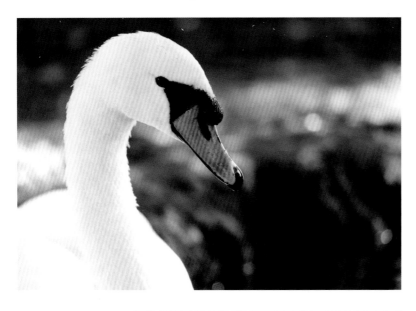

MUTE SWAN
Abbotsbury Swannery
Dorset

'Looking at You'

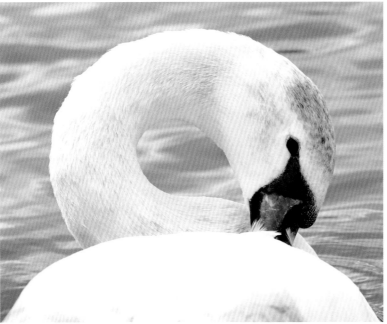

MUTE SWAN
Trinity Waters
Nr Bridgwater, Somerset

'Circle Neck'

BEWICK'S SWAN
Slimbridge

'Bewick in Feather Water'

Oliver is fascinated by the beautiful feather-like patterns in the water around the swan in this image.

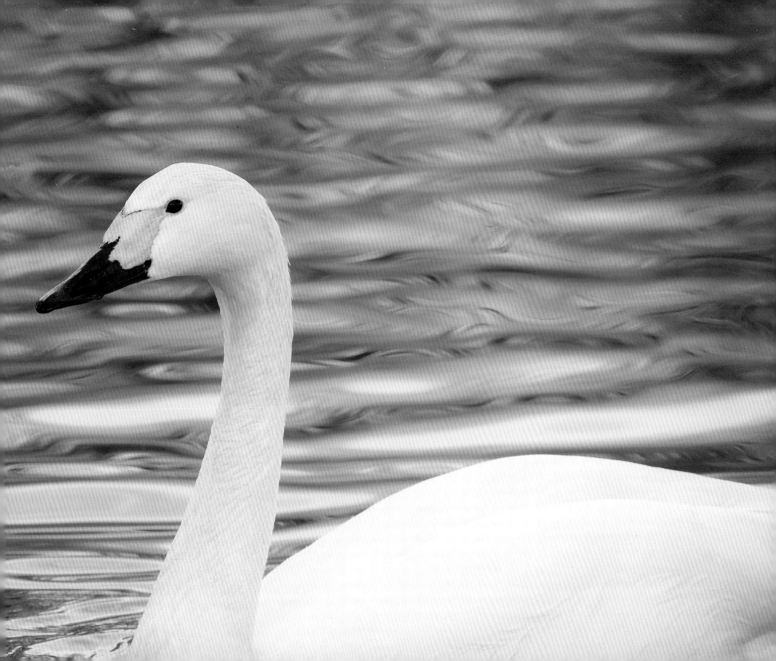

MUTE SWAN
Abbotsbury Swannery, Dorset

'Swan in the White Sea'

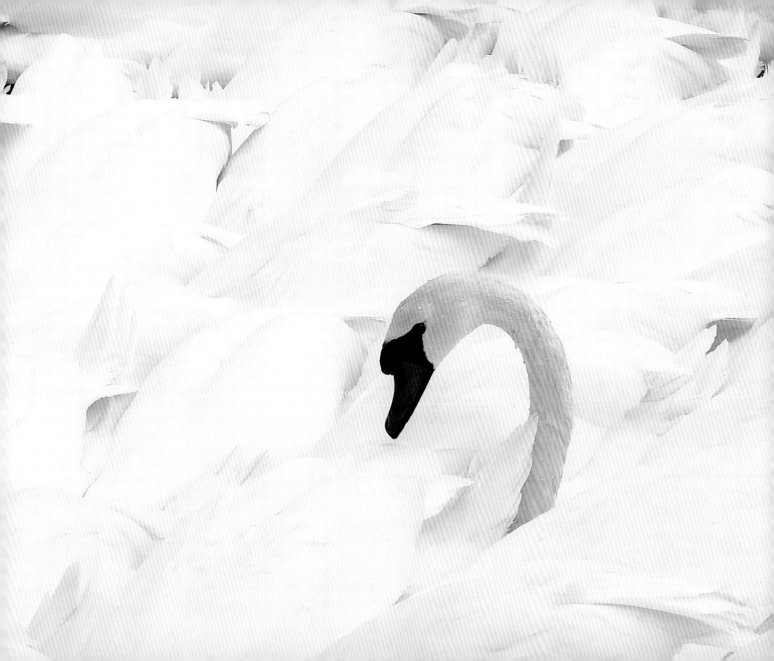

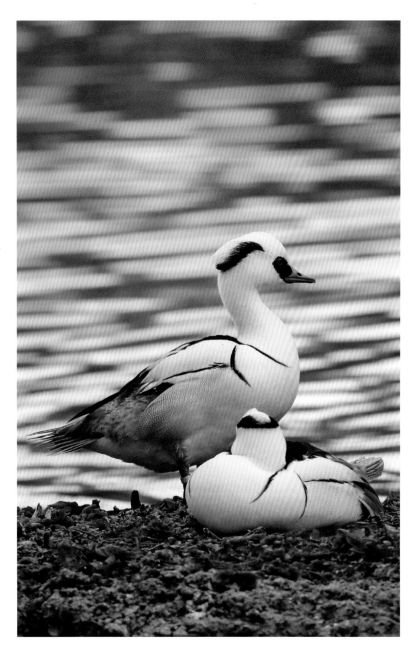

SMEW
Slimbridge

SHELDUCK
Slimbridge

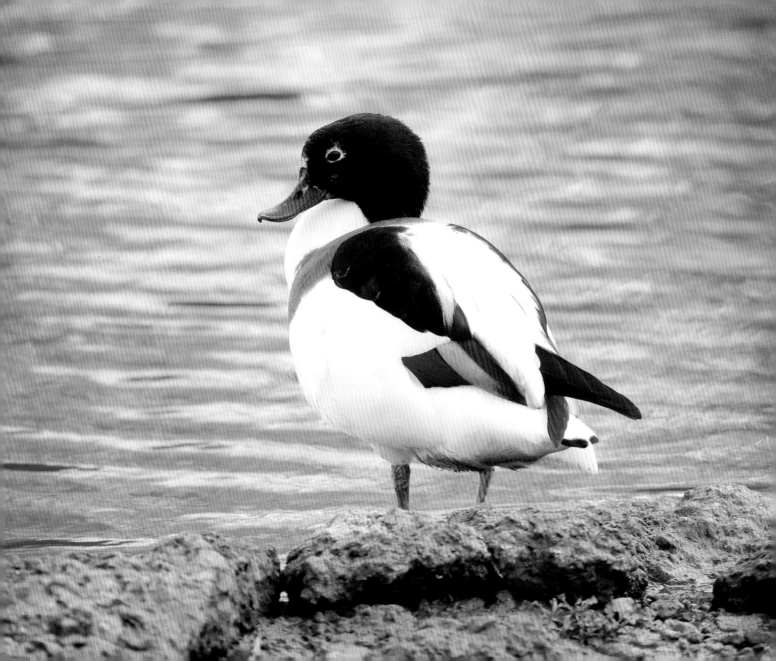

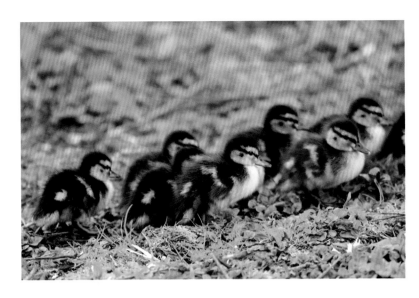

MALLARD
The Sedges Fishery,
Nr Bridgwater, Somerset

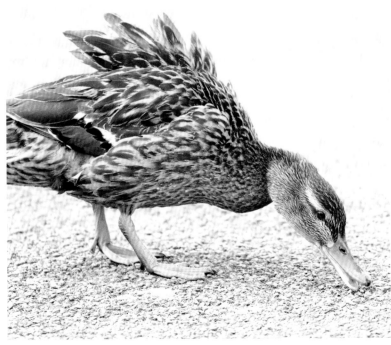

MALLARD
Chard Reservoir, Somerset

'Wind in your Feathers'

MALLARD
Slimbridge

'Having a Splash'

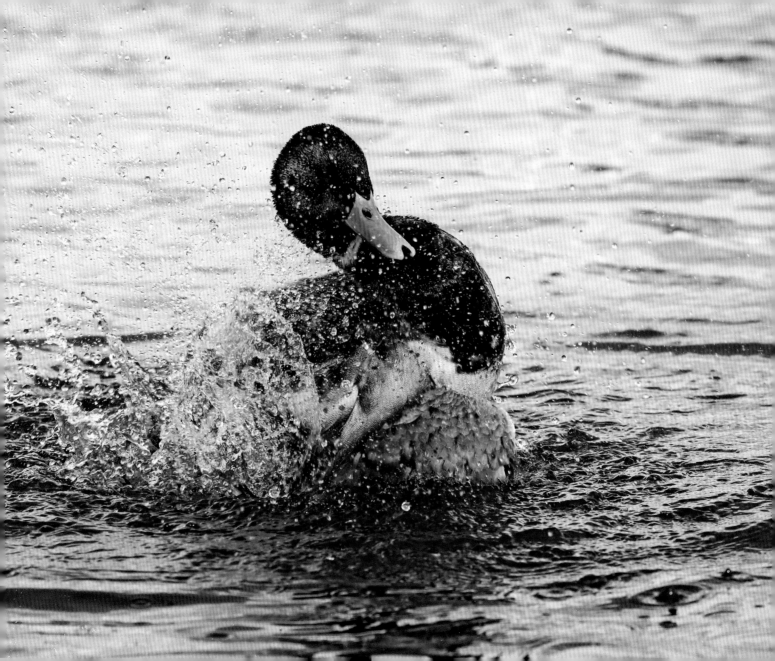

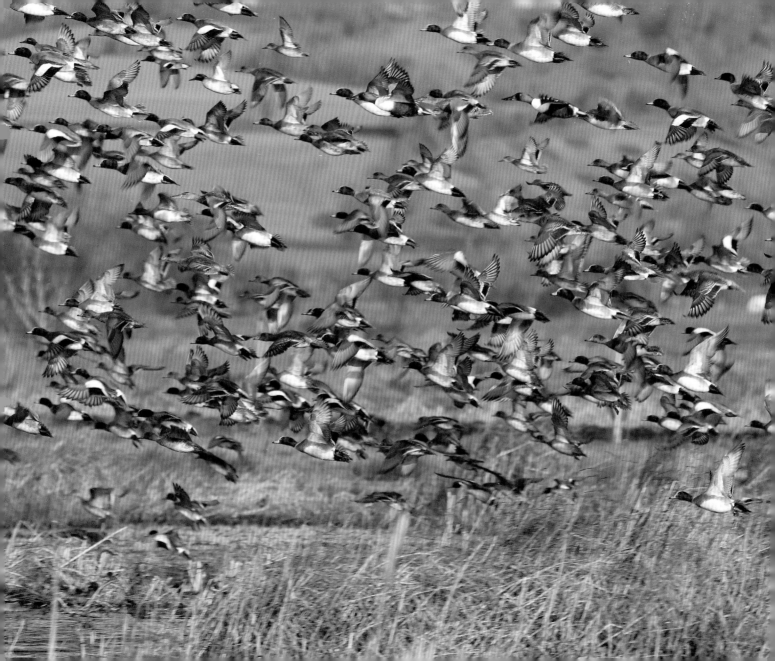

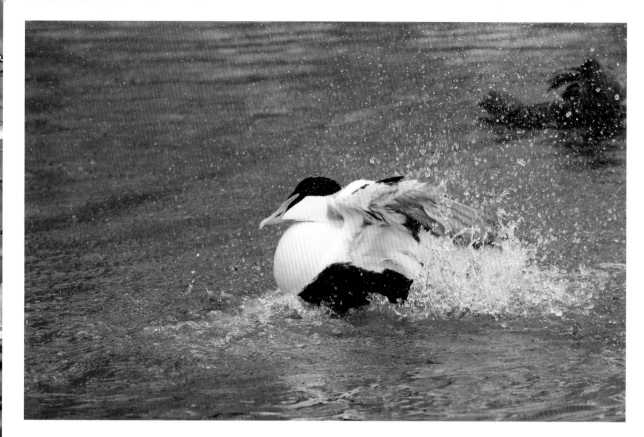

DUCKS IN FLIGHT
Greylake RSPB Reserve,
Somerset

'Ducks in Flight - Primarily
Wigeon, some Shoveler'

EIDER
Slimbridge

'Splashing!'

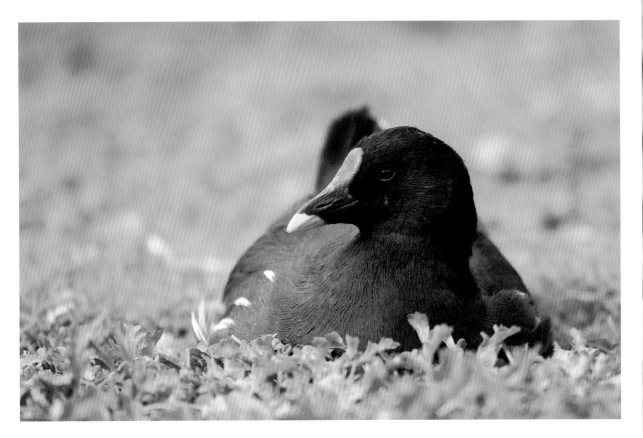

MOORHEN
Slimbridge

COOT
Slimbridge

'Coot in Golden Water'

Oliver loves the bright golden leaves floating in the dark water, as well as the coot.

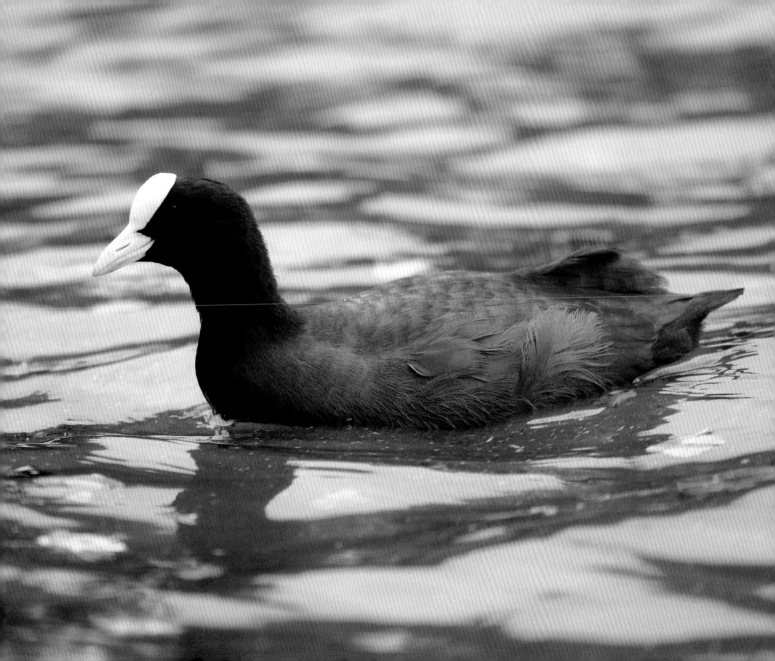

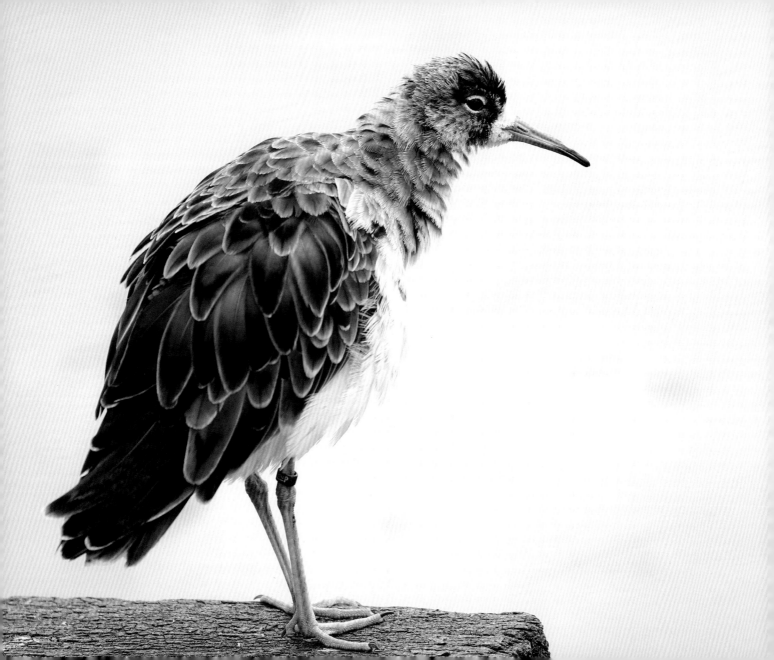

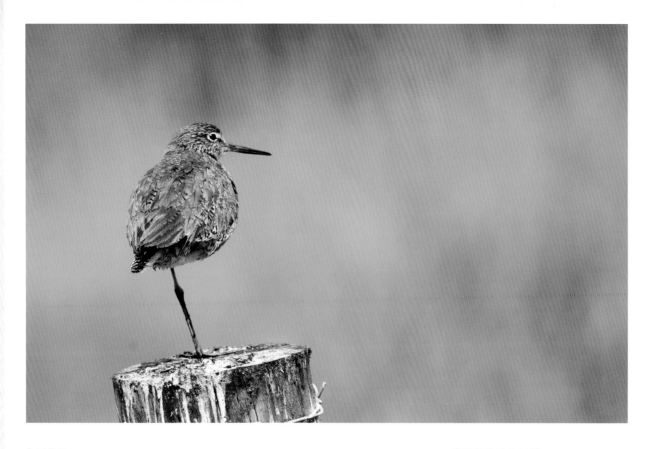

RUFF
Slimbridge

Oliver reckoned this guy looked
as if his football team had just
lost!

REDSHANK
Ham Wall RSPB Reserve,
Somerset

'The Balancing Redshank'

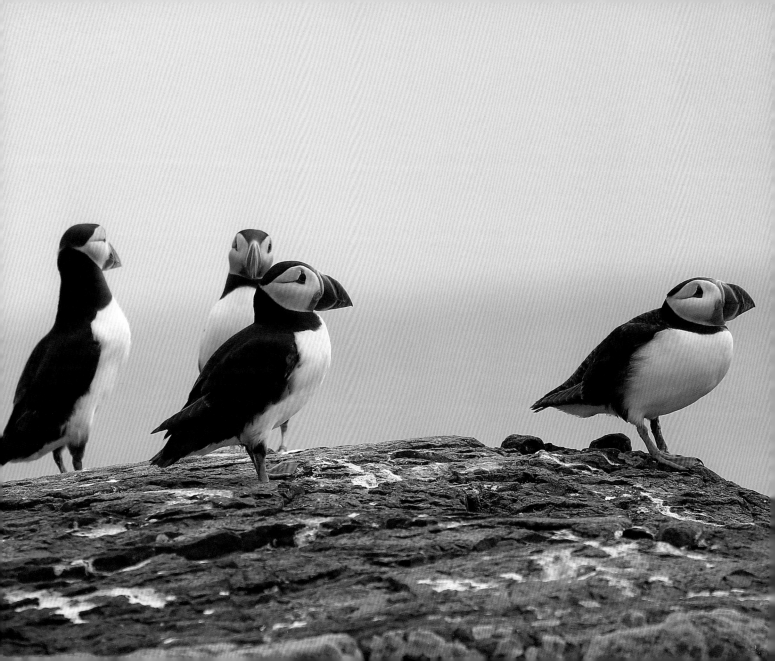

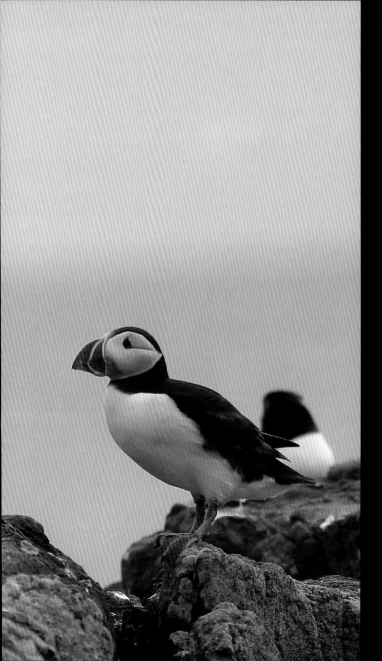

SEA BIRDS

Almost all these images were captured on the Farne Islands off the Northumberland Coast. Joy Pettifer from Billy Shiel's Boat Trips, Seahouses, very kindly organised two complimentary boat trips for Oliver and Mike to get out to the islands to capture puffins for the first time. Mike captured Oliver and his new friend Jim Bennett (whom he met on the boat) getting attacked by Terns, as is the norm during the breeding season – all part of the difficulties a wildlife photographer has to put up with! The sheer numbers of birds seen from the boat, nesting on the rocks and cliffs, is spectacular – an experience to be recommended whether you are a photographer or not.

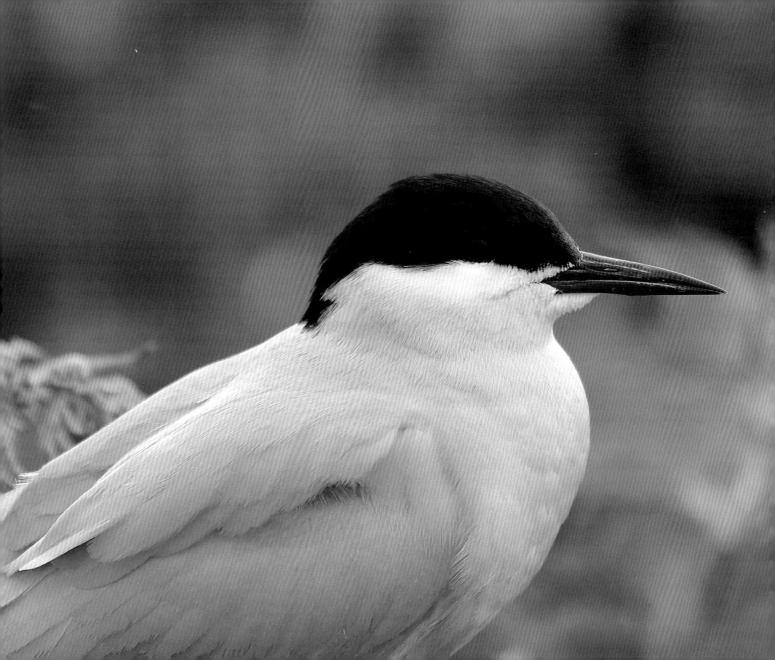

ARCTIC TERN
Farne Islands, Northumberland

'Looking Sharp!'

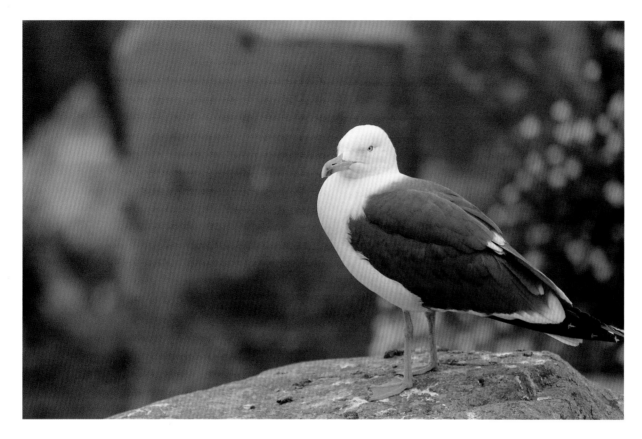

LESSER BLACK-
BACKED GULL
Farne Islands, Northumberland

HERRING GULL
Farne Islands, Northumberland

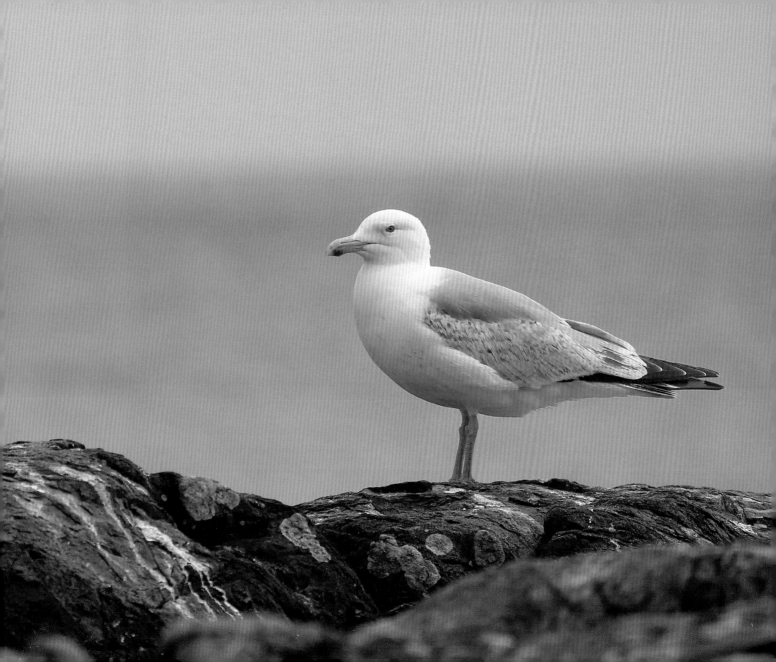

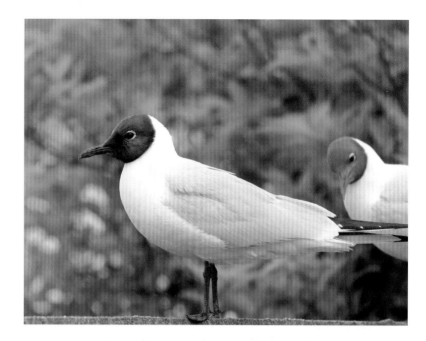

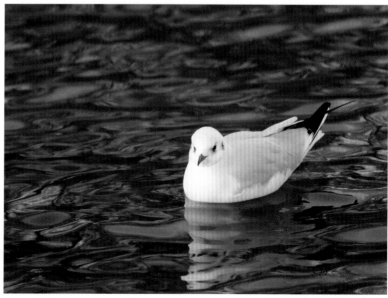

BLACK-HEADED GULL
Farne Islands, Northumberland

Left: 'The Little Chick'
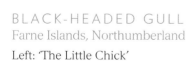

Bottom right: A black-headed gull in winter, when the feathers on their heads are white.

KITTIWAKE
Farne Islands, Northumberland

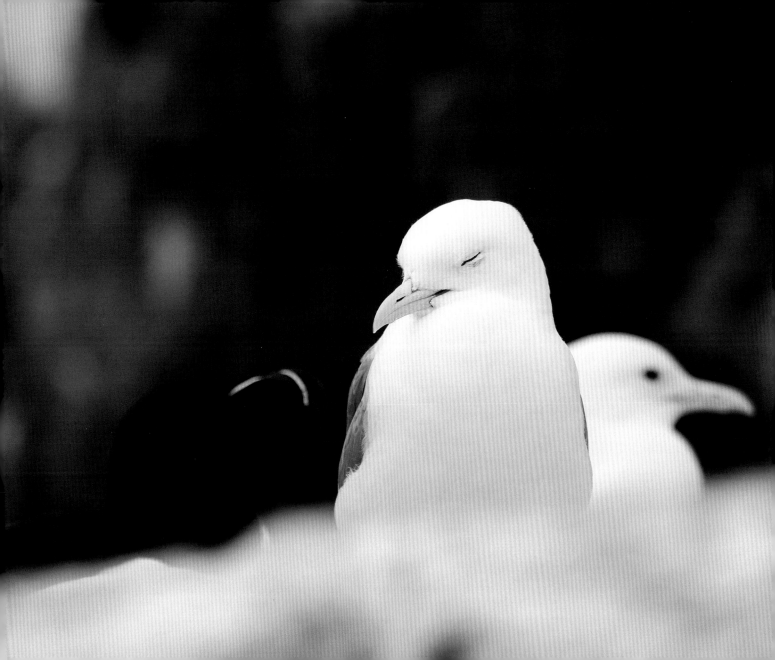

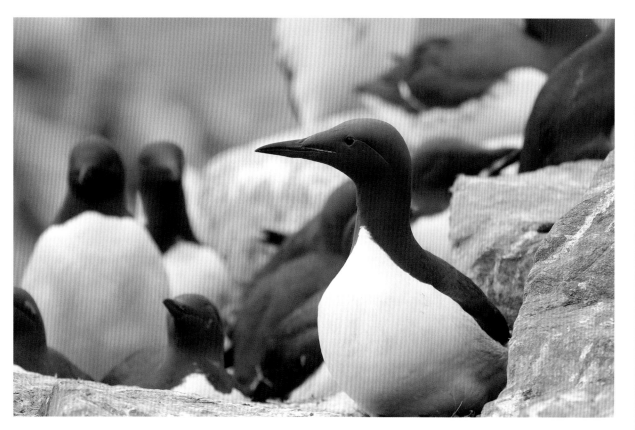

GUILLEMOT
Farne Islands, Northumberland

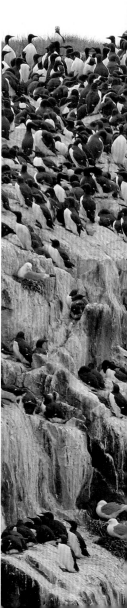

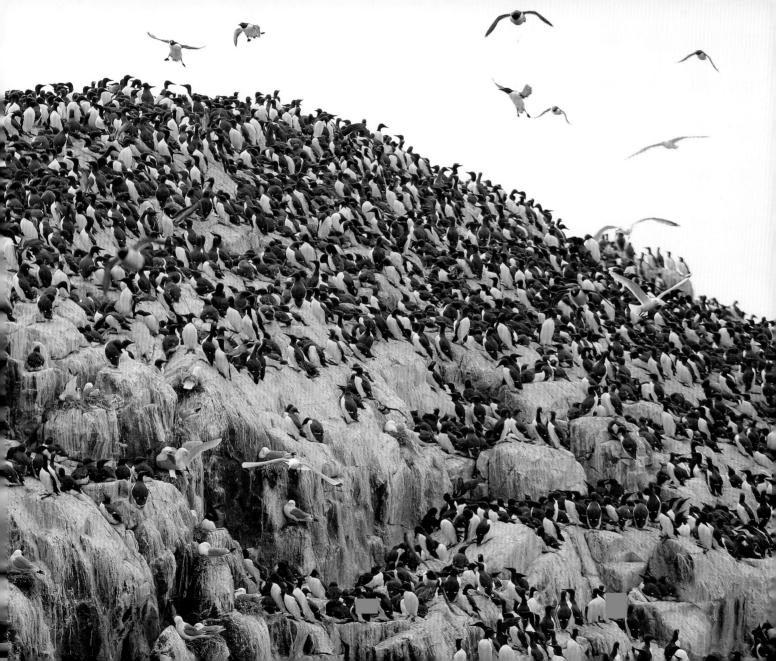

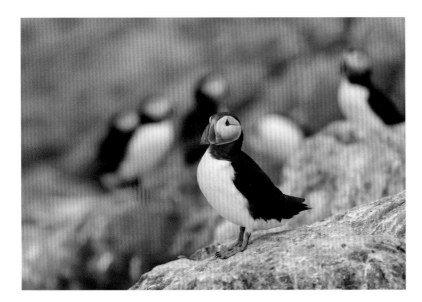

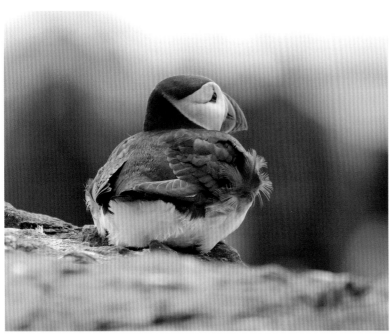

PUFFIN
Farne Islands, Northumberland

Top left: 'Proud and Perfect Puffin'

Left: 'Dreamin'...'

Right: 'Puffins Nattering'

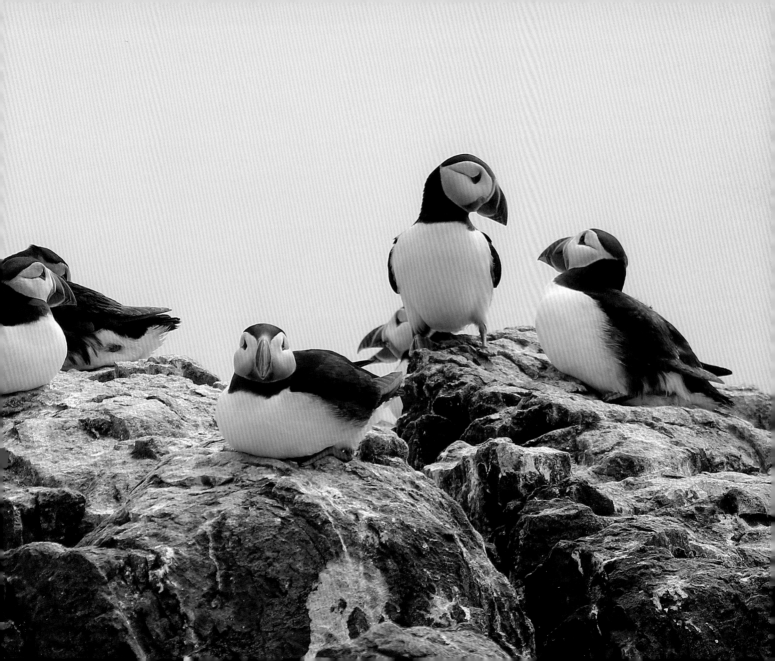

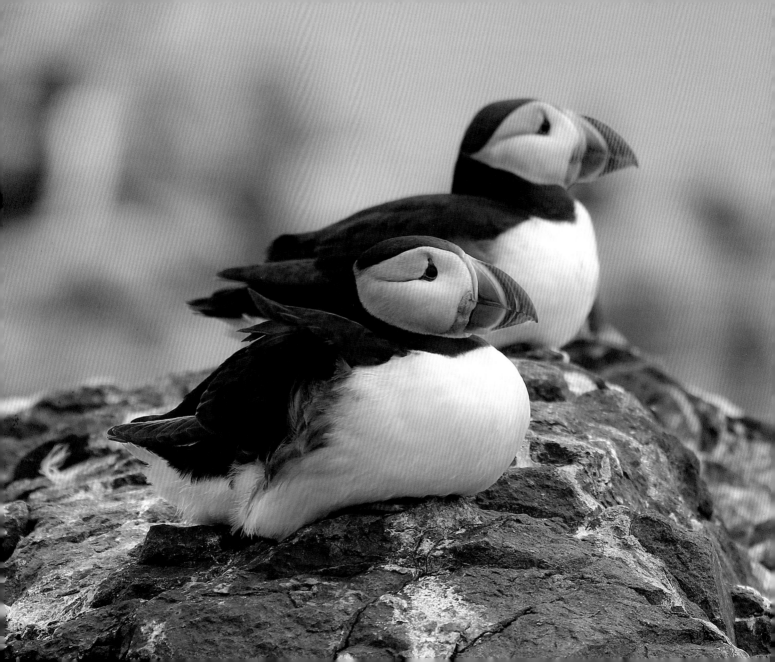

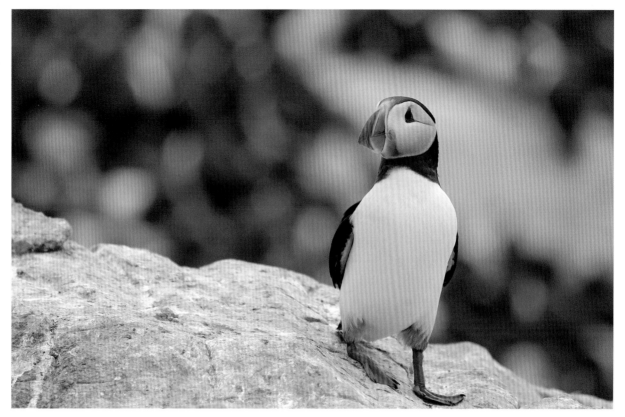

PUFFIN
Farne Islands, Northumberland

Left: 'Bert and Ethel'

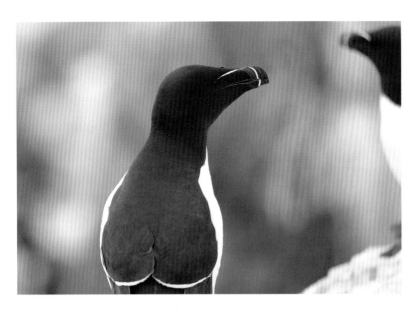

RAZORBILL
Farne Islands, Northumberland
'Angry!!'

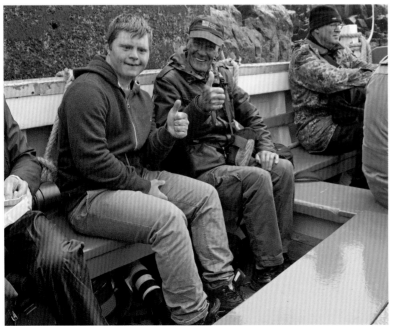

SHAG
Farne Islands, Northumberland

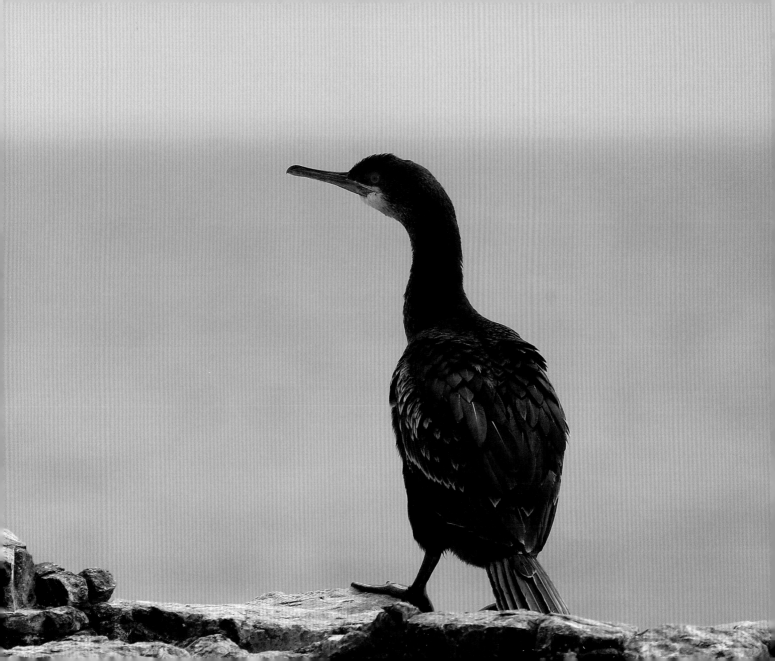

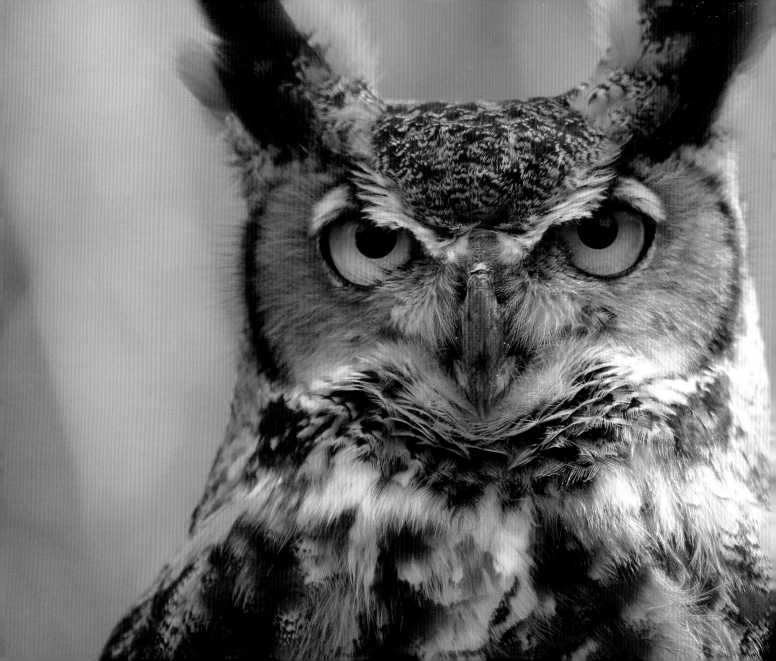

BIRDS OF PREY

Oliver is genuinely interested in, captured by, and thoroughly enjoys, all birdlife, but if he has to pick a favourite category, then he chooses birds of prey. He is fascinated by their speed and agility, whilst finding himself transfixed by the 'look' of a bird of prey, and always concentrates on getting the 'eye' of the bird sharp and in focus.

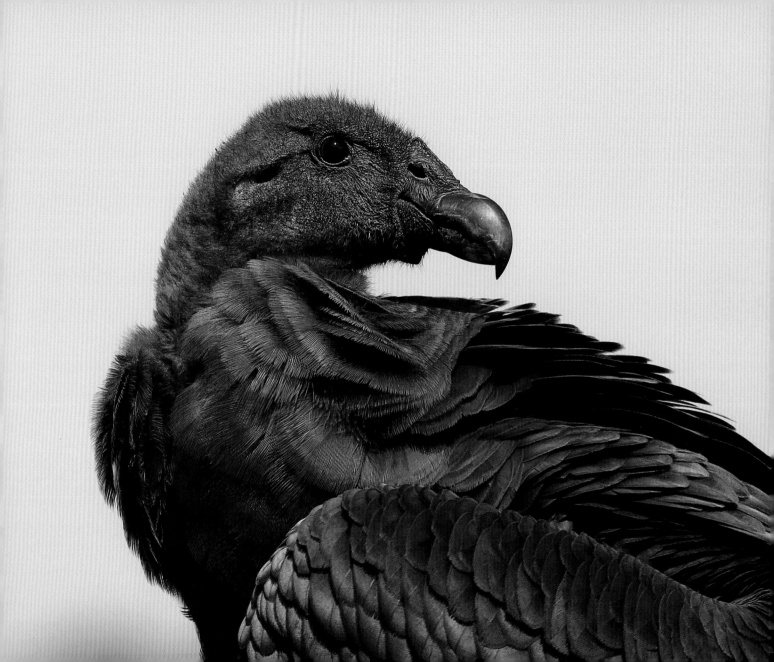

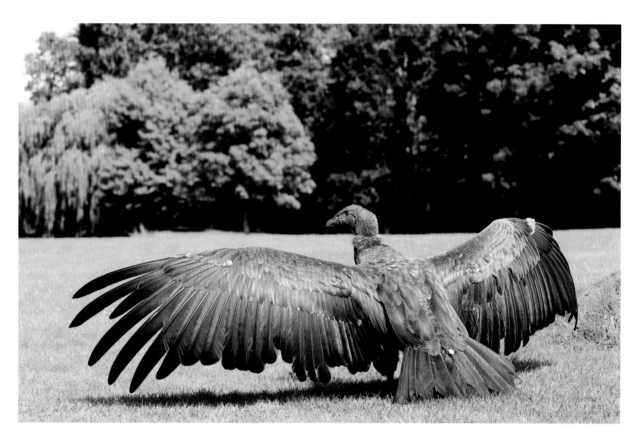

ANDEAN CONDOR
Moccas, ICBP

Oliver was amazed at the sheer size of this Andean condor at the ICBP (and Moccas is still only a juvenile).

Oliver gasped "Look at that! It's MASSIVE!" as it flew into the display area and hopped around on the grass.

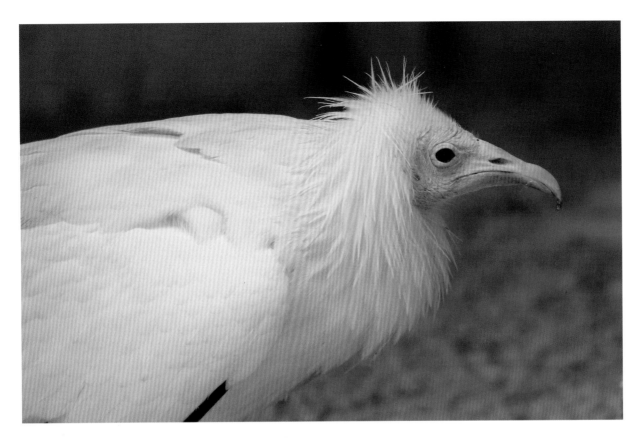

EGYPTIAN VULTURE
Pinotage, ICBP

EURASIAN
GRIFFON VULTURE
Delectable, ICBP

Oliver was fascinated by this vulture called Delectable at the ICBP and took a whole series of images, but this is his favourite.

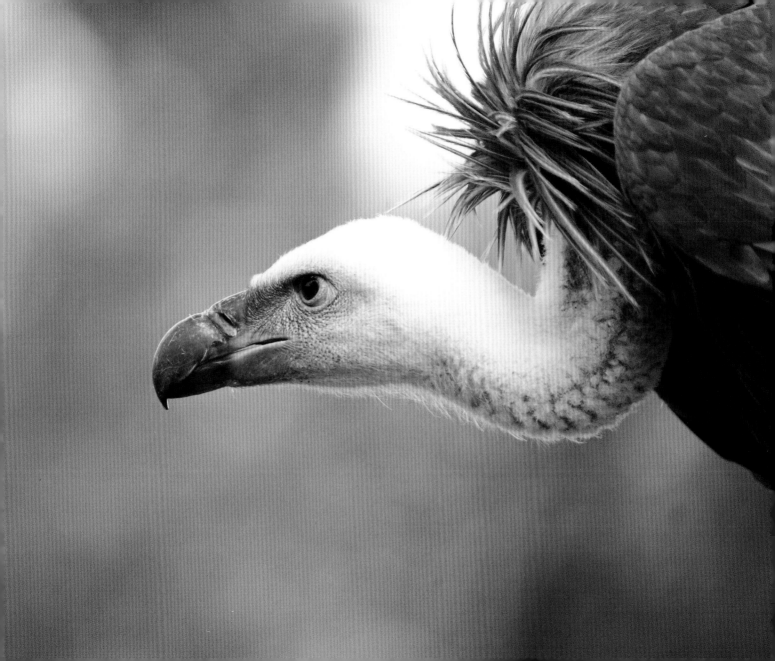

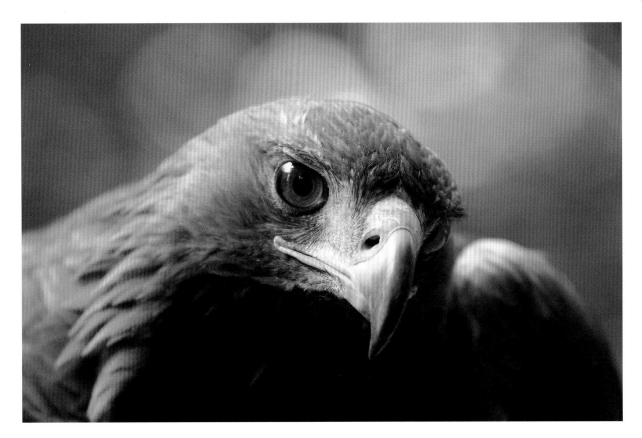

"Such a remarkable, breathtaking and bewitchingly beautiful bird."

When filming for the BBC's *The One Show* at the Loch Lomond Bird of Prey Centre, Oliver was introduced to Orla the Golden Eagle.

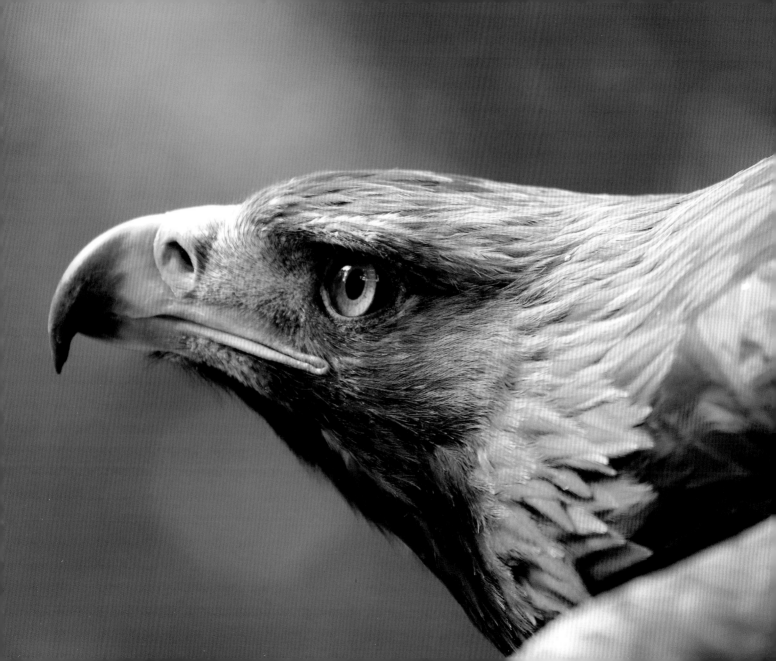

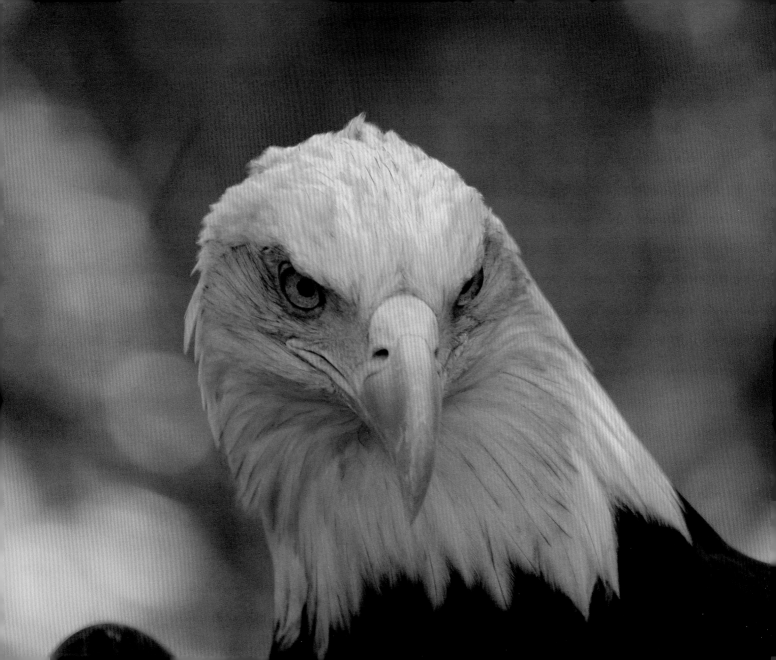

BALD EAGLE
Majesty, AEF

'You don't mess with me...'

In November 2017 Tennessee Tourism commissioned Oliver to travel to the Smoky Mountains in Tennessee and capture the area in his own inimitable style. They introduced him to Ken Jenkins, a professional landscape and wildlife photographer who has lived in the area all his life and shares a passion for birdlife. Ken took Oliver to meet his friend Al Cecere, Founder of the AEF, who kindly spent the afternoon presenting a host of utterly fabulous birds of prey for Oliver and Ken to photograph. This stunning bird is called Majesty – and majestic she most surely was!

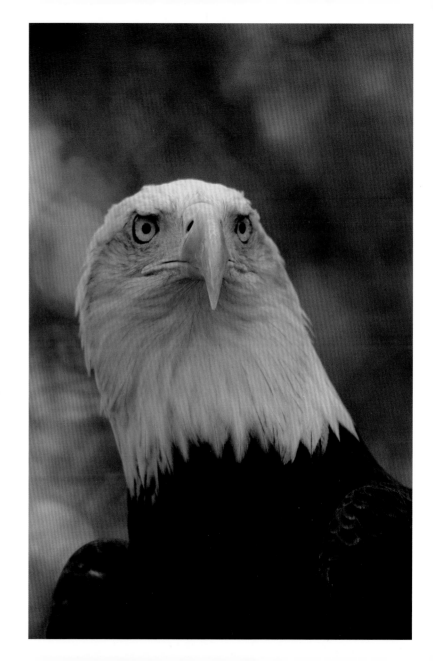

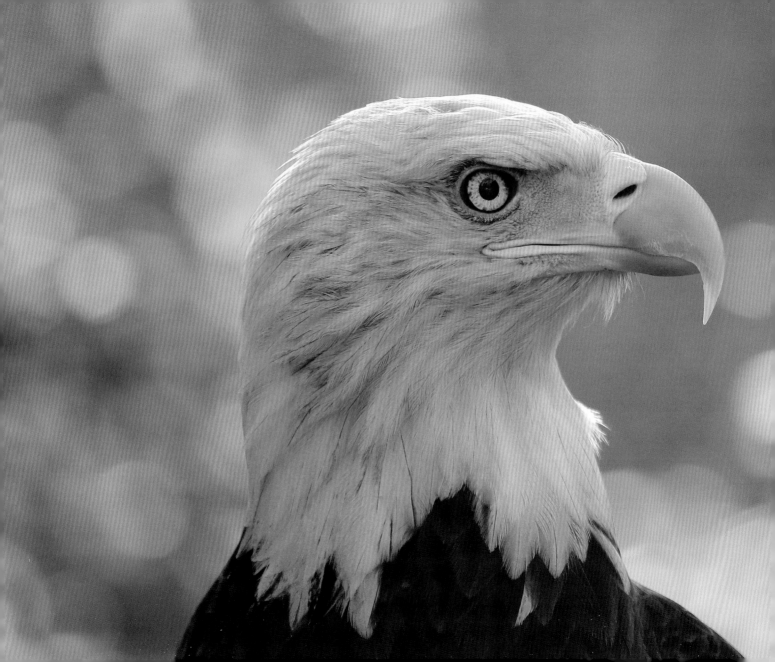

BALD EAGLE
Challenger – The Iconic
Symbol of America, AEF

This is a rather famous eagle
in the US. The bald eagle is
the symbol of America and
at large, impressive and key
occasions and events in the US,
such as the annual Superbowl,
a bald eagle is brought in to
fly around the stadium as part
of the ceremony – and THIS
is that very eagle. His name is
Challenger and he is owned
by Al Cecere who is Founder
and President of the American
Eagle Foundation in Tennessee.
Al has dedicated his life to the
rehabilitation and recovery
of injured bald eagles and
other birds of prey, as well as
instigating and funding vital
breeding programmes.

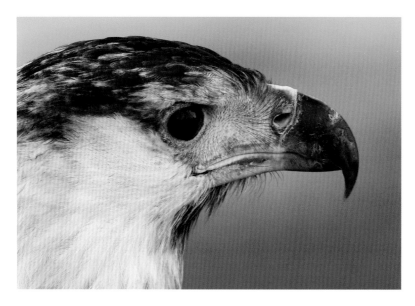

AFRICAN FISH EAGLE
Mathon, ICBP

Oliver loves to take close-ups of birds, often just the head and shoulders, and at the ICBP there is plenty of opportunity to do that.

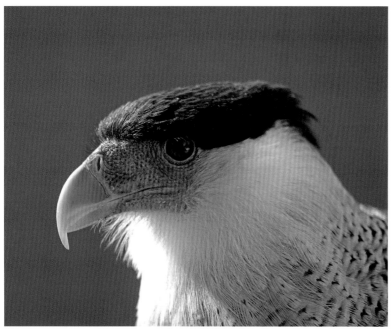

CRESTED CARACARA
Elvis, AEF

Oliver LOVED that the Caracara at the AEF was called Elvis!

GOSHAWK
Jess, LLBPC

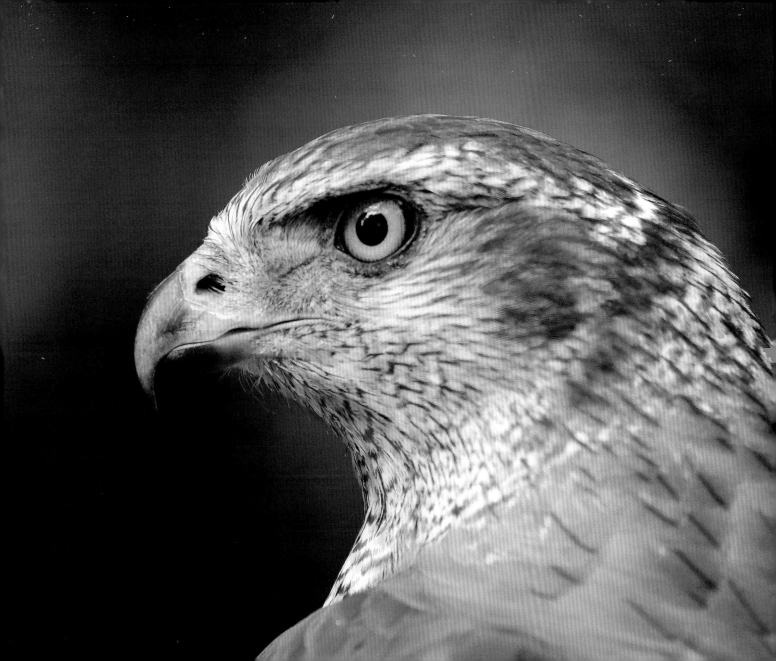

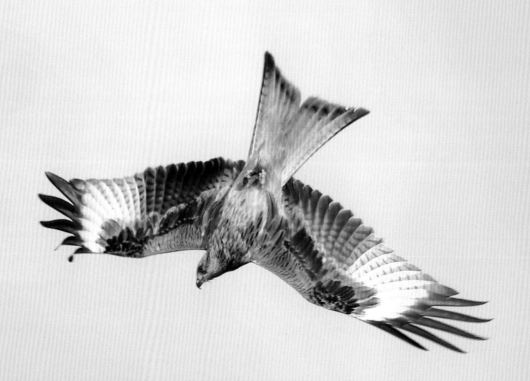

RED KITE
Gigrin Farm, Wales

'Tumbling in the Sky'

Wales is one of Oliver's most
favourite places in the world,
and during one of his many
holidays there he visited Gigrin
Farm where every day they feed
the wild red kites. It was a real
challenge for Oliver to capture
the birds, as they moved so fast!
But he loved this 'tumbling'
shot that he managed to capture
on the day.

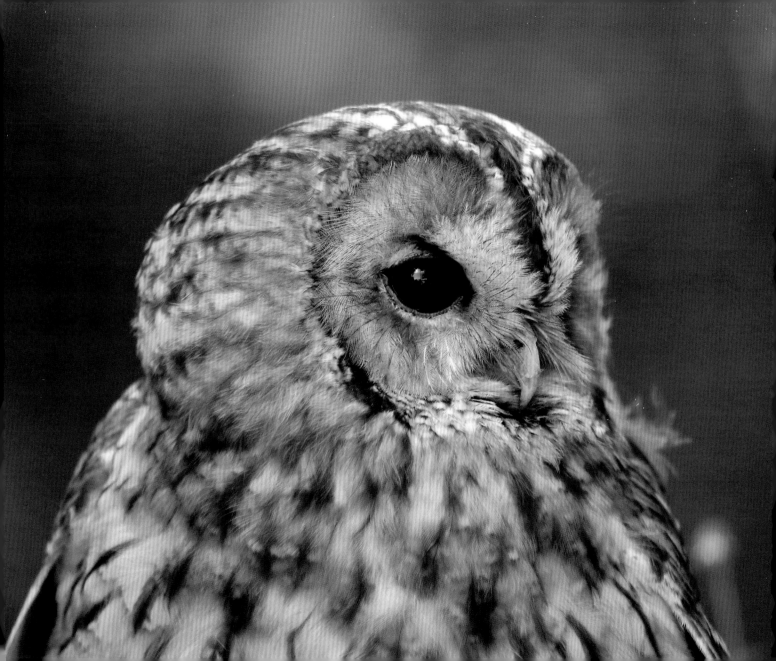

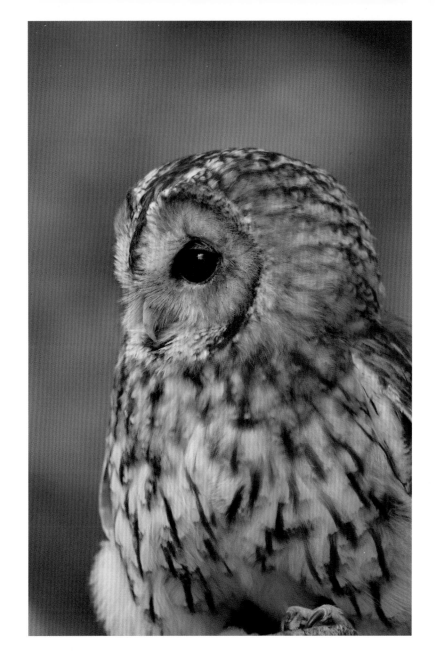

TAWNY OWL
LLBPC, Scotland

'Dear Little Chap'

Oliver was particularly fond
of Bernie and asked Stewart
Robertson, the founder at
LLBPC, if he could 'hold' him.

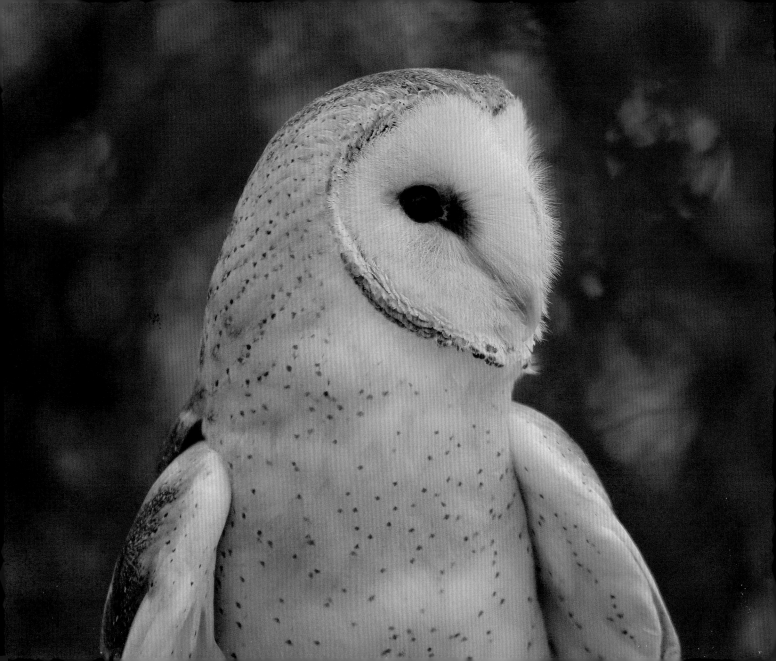

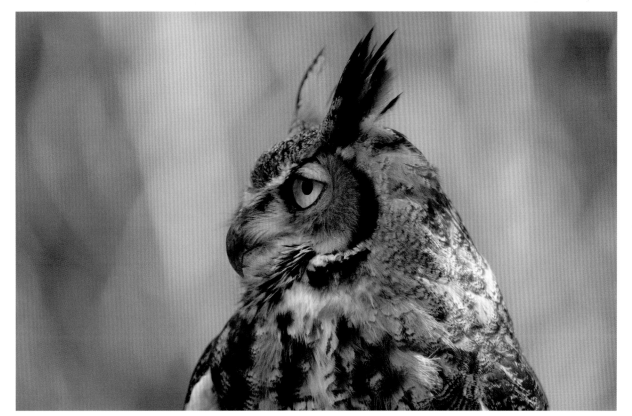

BARN OWL
Jupiter, AEF

GREAT HORNED OWL
AEF

GARDEN BIRDS

Living in the Blackdown Hills on the Somerset/
Devon border, Oliver is fortunate enough to
enjoy a large front garden, a very large back
garden, and to be surrounded by hills, woods,
and fields. The number of different species
noted in Oliver's list of birds seen at his home
currently stands at 41.

Although some, such as goldcrest and bullfinch,
remain elusive and too difficult as yet for Oliver
to capture on camera, he is extremely pleased
and proud of all the bird images he has caught
at home.

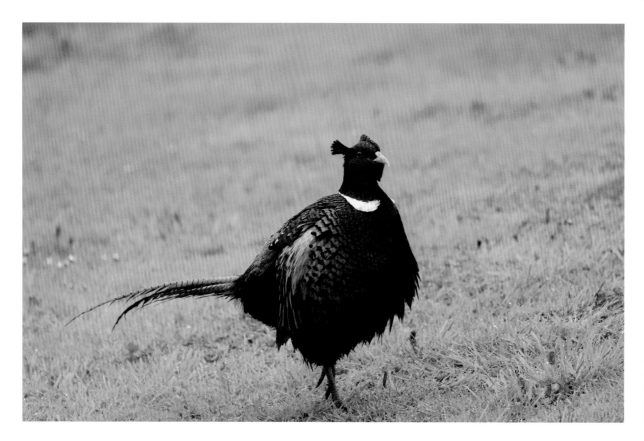

"This is just one of those pictures that makes people smile!"

PHEASANT

Right: This image is 'The Attention-seeking Pheasant' and is an amazingly popular image, receiving multiple orders for prints from both the UK and the US.

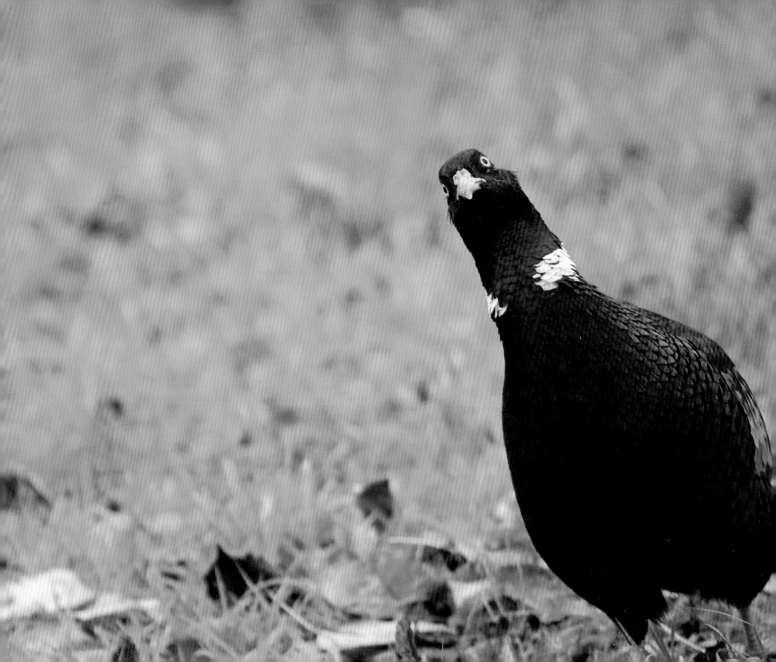

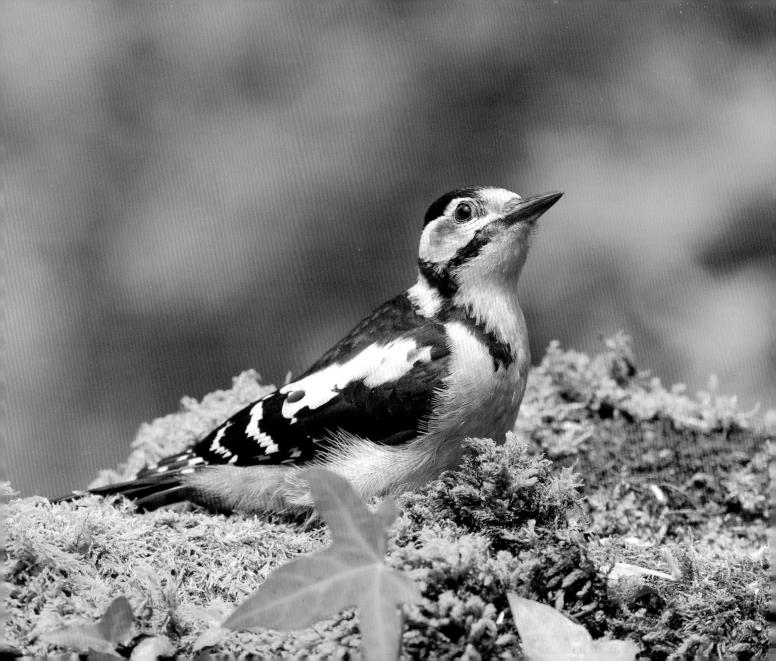

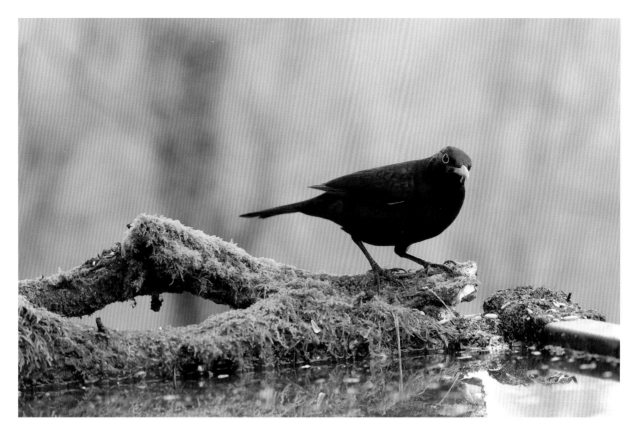

GREAT SPOTTED
WOODPECKER

BLACKBIRD

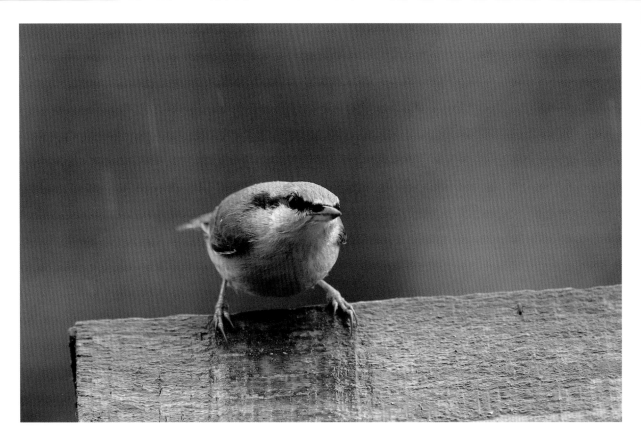

NUTHATCH

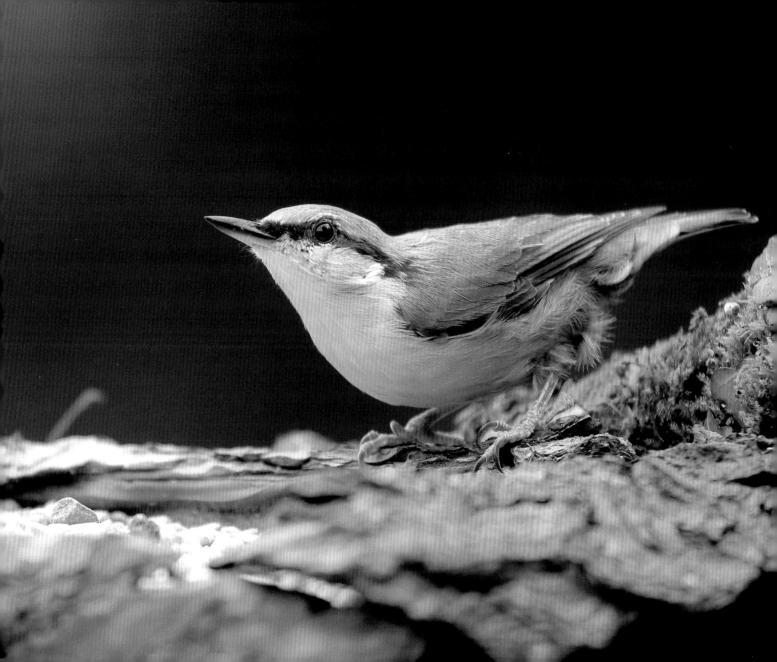

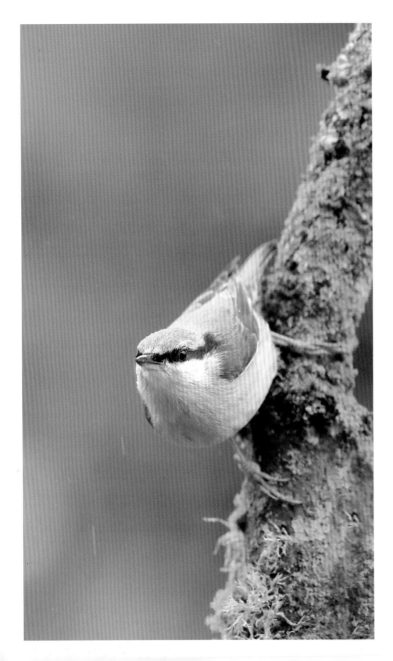

NUTHATCH

These are great birds to capture on camera, both because of their colour and their unusual stance.

Left: Love this shot!

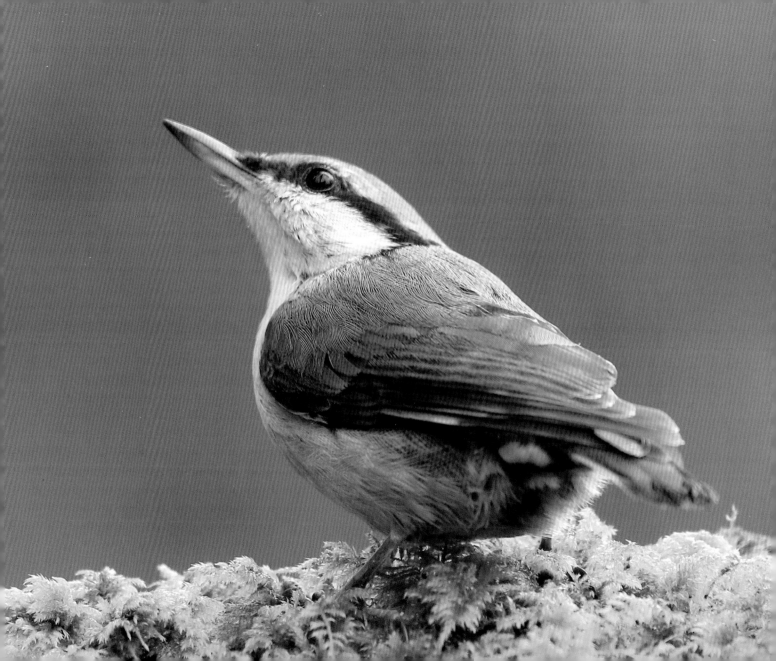

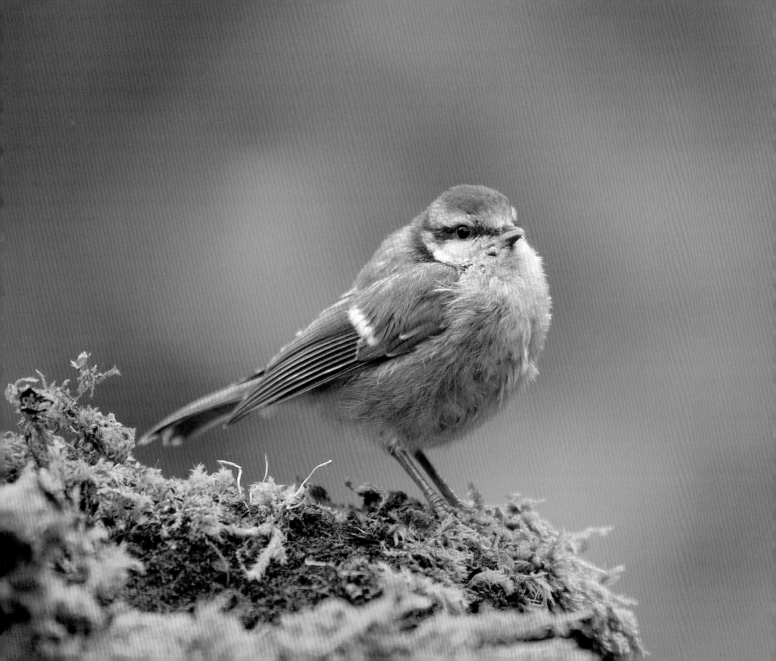

BLUE TIT

Left: This is a beautiful shot of
a juvenile blue tit before any
yellow plumage has arrived.
It's fluffy, it's got a range of
stunning blues, it's got a great
expression – what's not to love?!

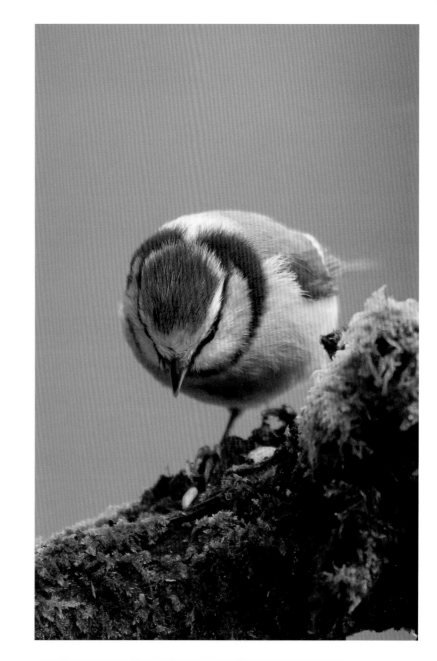

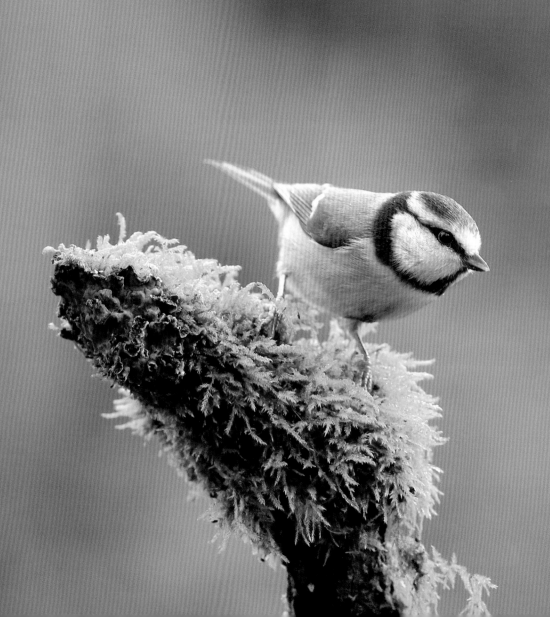

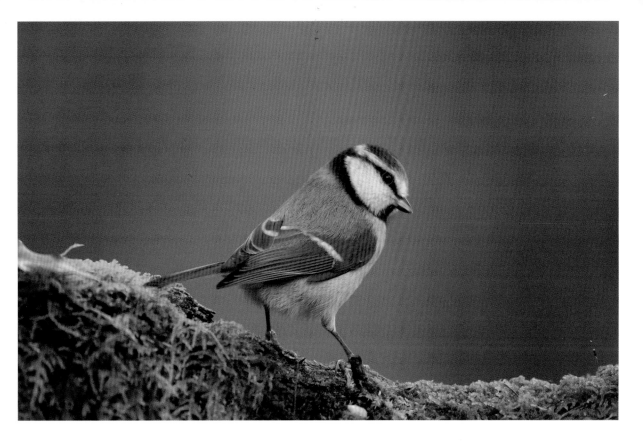

BLUE TIT

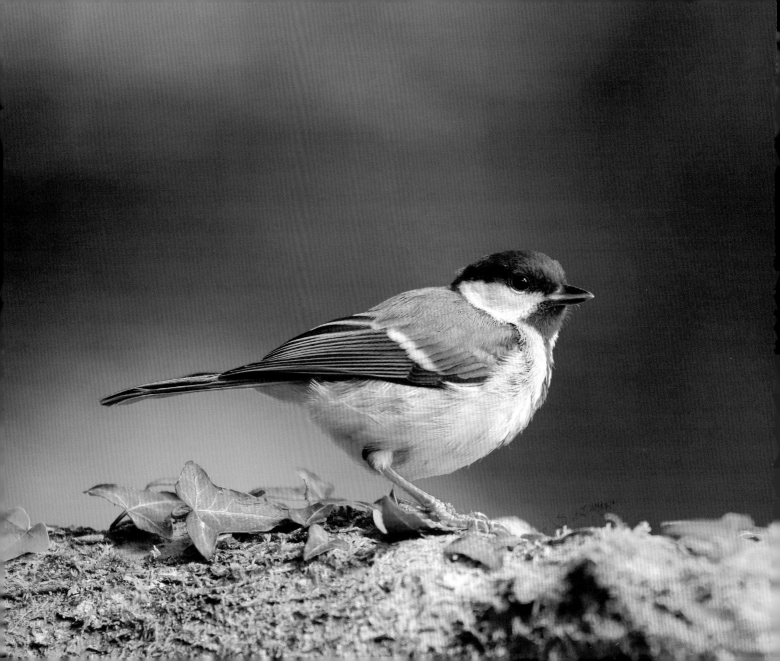

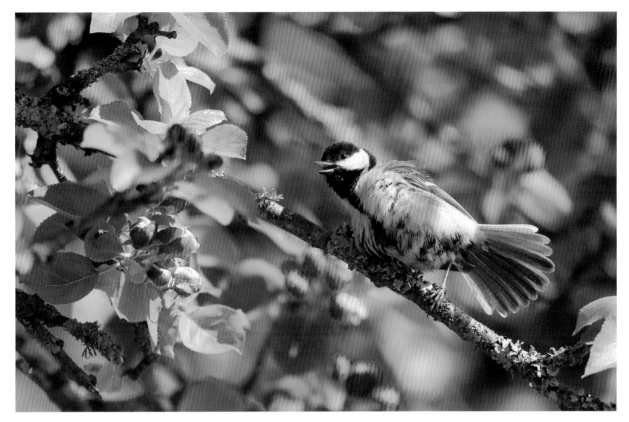

GREAT TIT

Above: A great capture of an unusual display by a great tit in our apple tree. We remain unsure as to whether it was displaying to impress the ladies, or to appear aggressive towards another male.

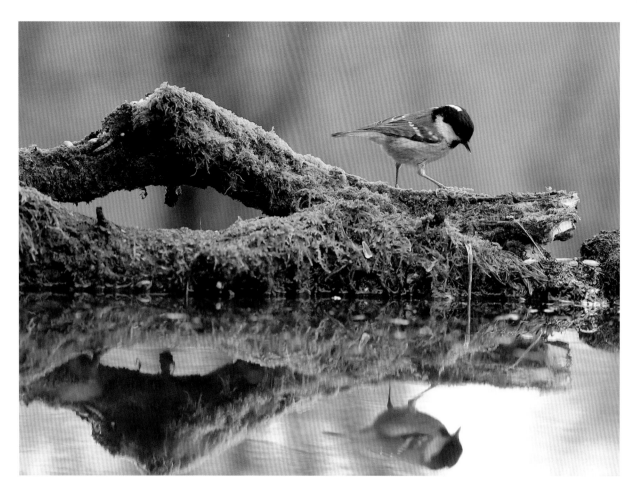

COAL TIT

MARSH TIT

Beside our garden reflection pool.

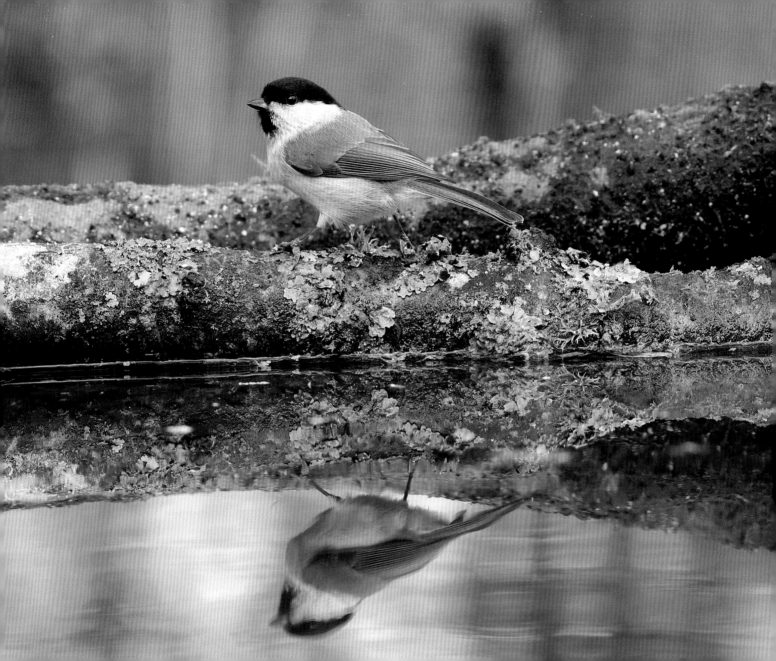

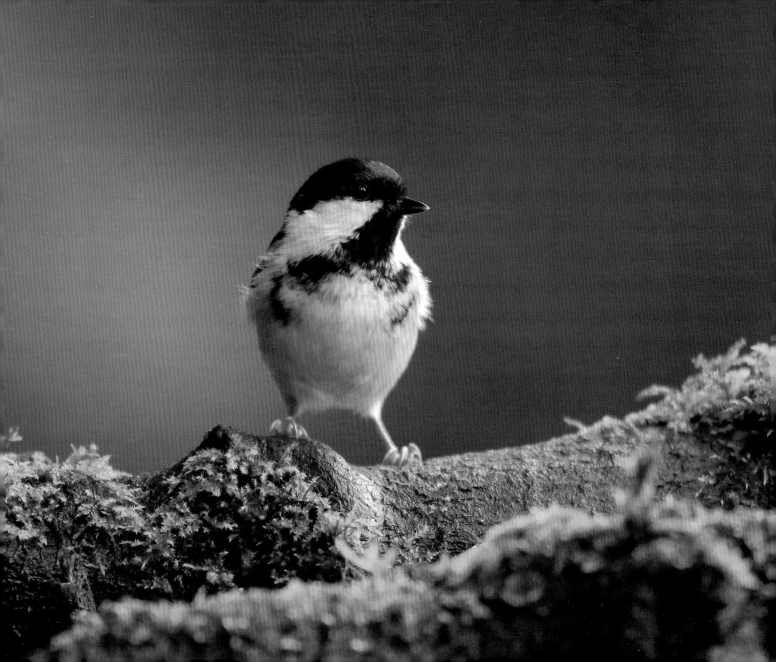

COAL TIT

LONG-TAILED TIT

Showing clearly the 'yellow
eyelid', which we hadn't noticed
before. Apparently these can
change from yellow to orange
or red.

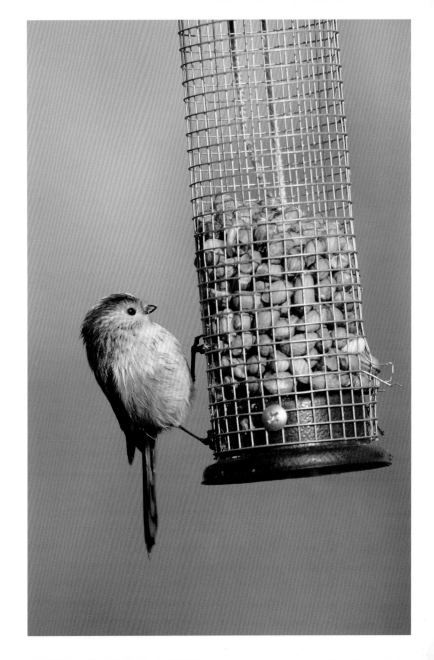

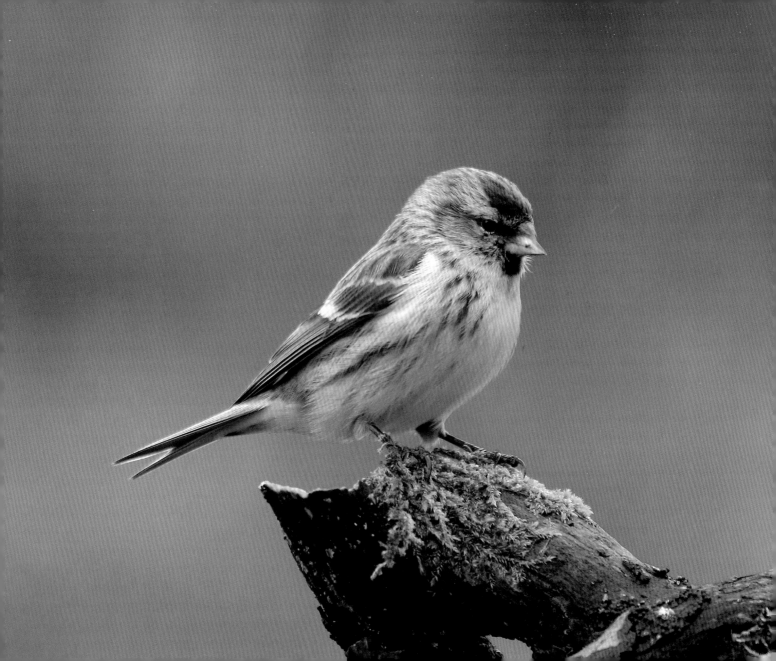

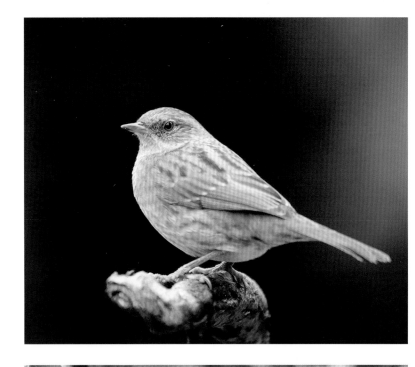

DUNNOCK

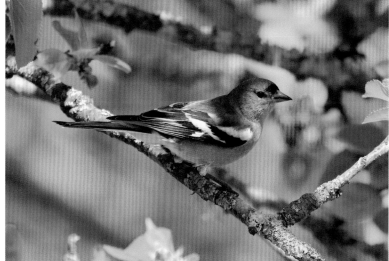

CHAFFINCH

REDPOLL

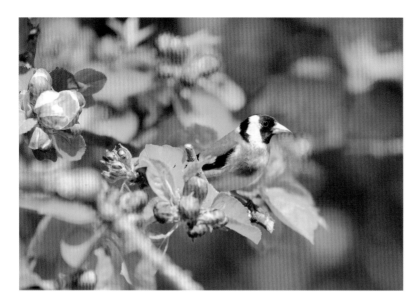

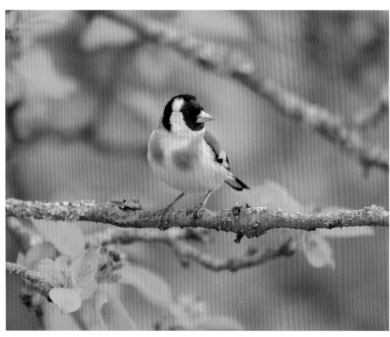

GOLDFINCH

Caught on camera in our apple tree.

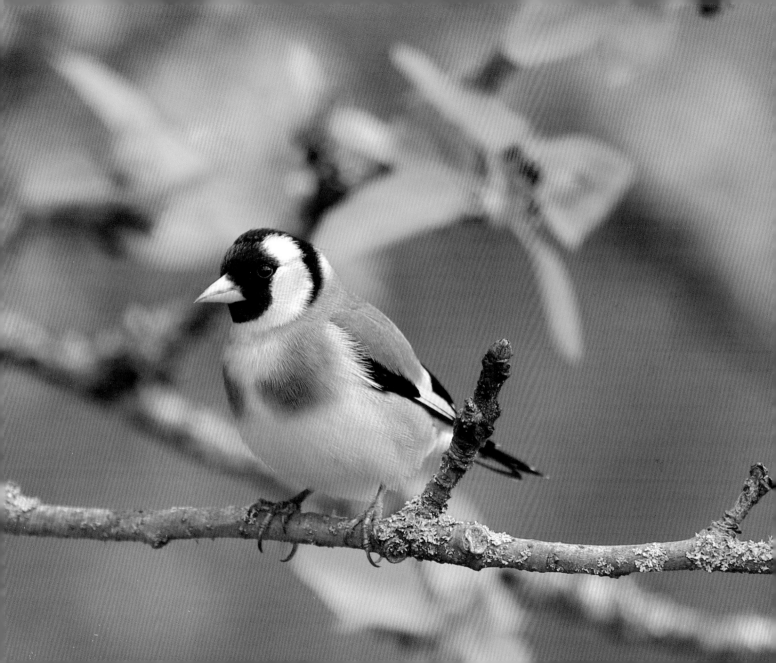

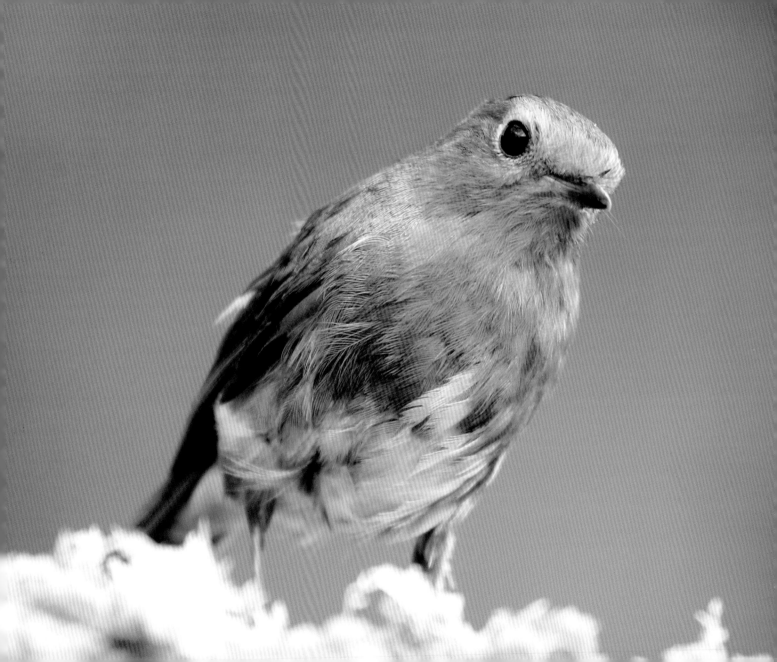

EVERYONE LOVES A ROBIN

The robin has already been voted Britain's favourite bird, and of that there is no doubt as Oliver receives more print orders for robins than any other bird. Consistently a UK favourite, images of these chirpy, lovable characters are also regularly sought by expats living abroad, who love to have a robin to remind them of home.

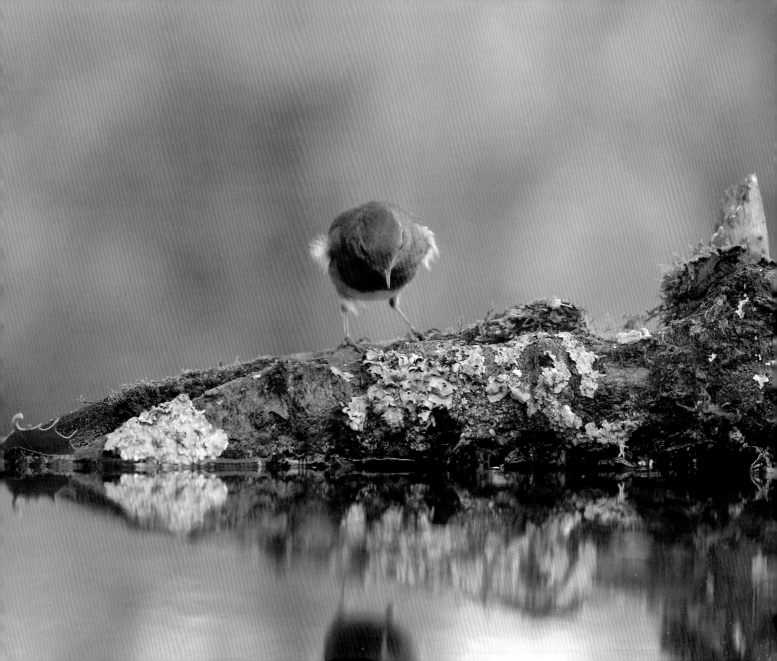

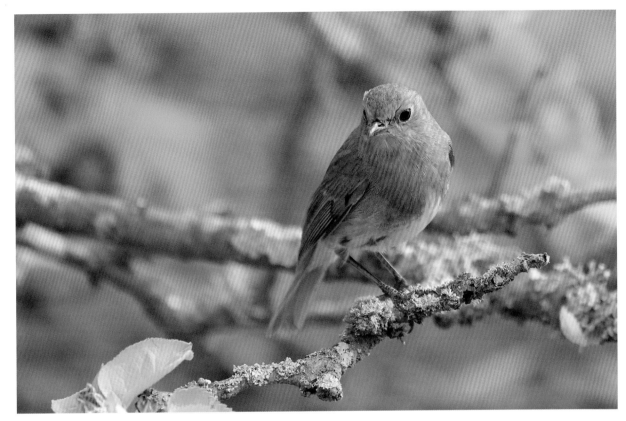

ROBIN

Left: 'Robin admiring his own
reflection'

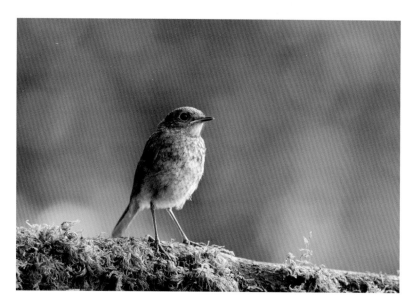

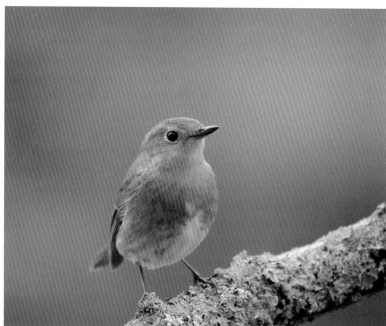

ROBIN

Right: Although this isn't as 'sharp' an image as it might be, there is something really interesting about the composition with the curved twig/shoot behind it.

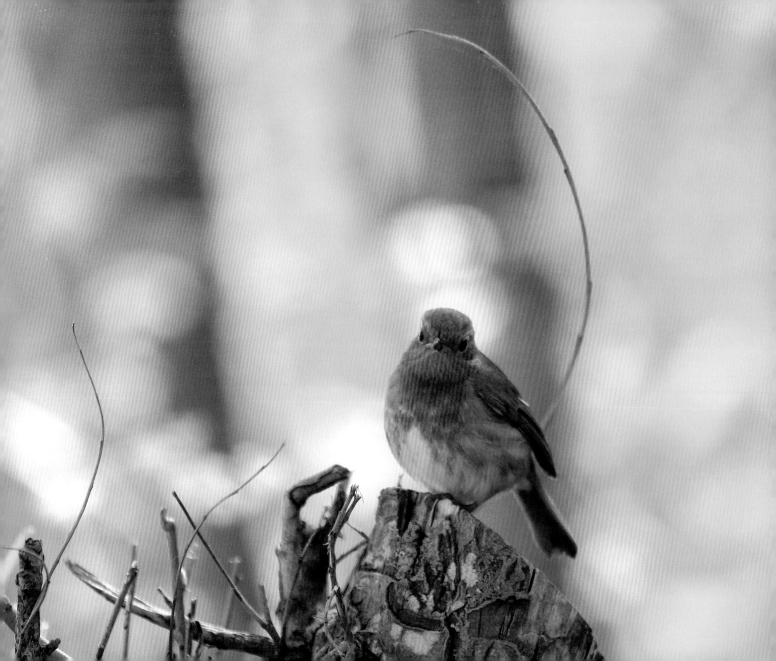

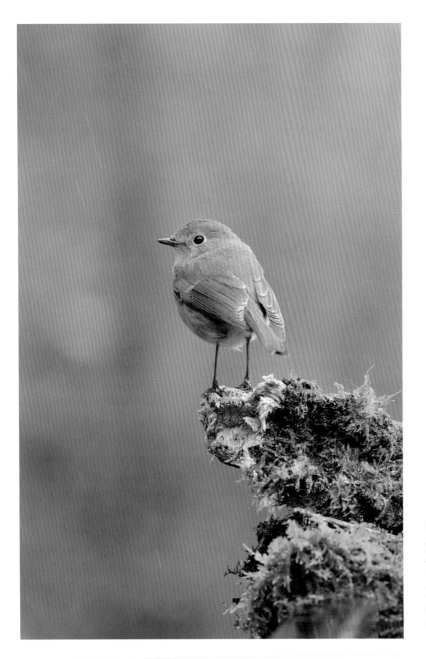

ROBIN

Left: 'Out on the edge and out in the rain'!

Right: Unlike most, Oliver is always happy to take a picture of a bird from behind!

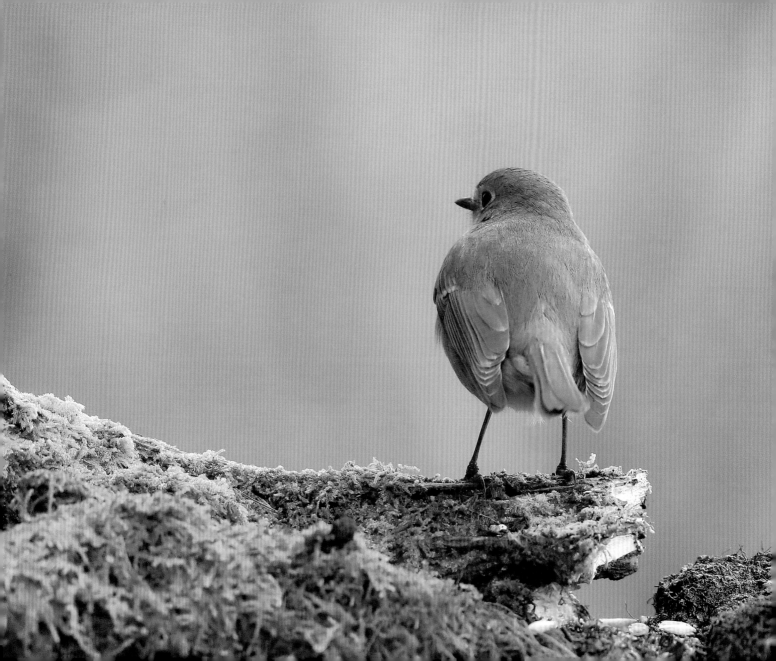

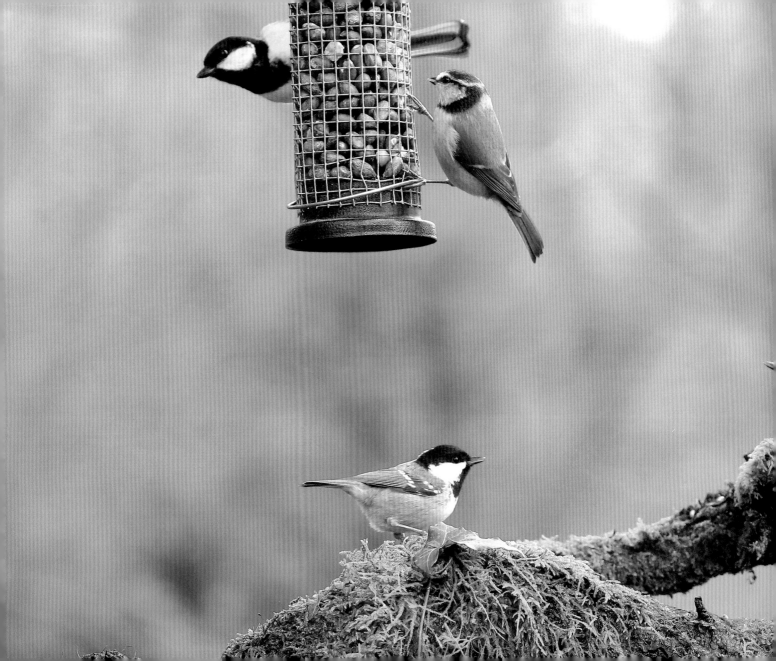

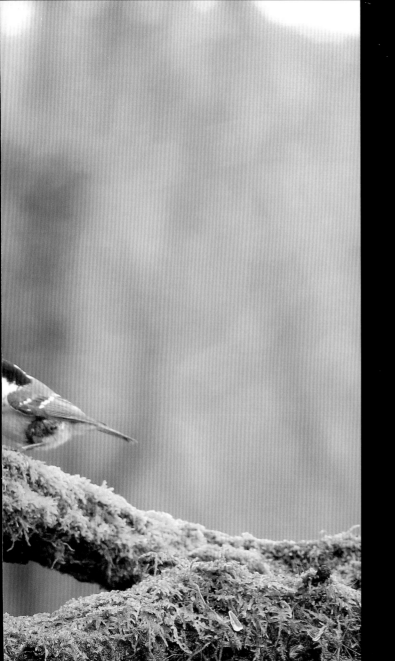

TRICKS OF THE TRADE

With photography, the first hurdle is often getting a person to hold the camera properly, but Oliver has a naturally stable stance and steady hand, and just did it! I have simply shown him how to get the best from his subject.

For bird photography we use: a shed with holes cut out of the sides at seat height, two mobile 'pop-up' hides, and a reflection pool which we built.

We use a variety of mossy logs and sticks as props on an old tripod for birds to land on, always placed near bird feeders.

With our reflection pool, we have feeders hanging above it permanently to attract the birds, and place suitable logs at the end. We put seeds in and on the logs and drill holes in some upright ones, pressing in peanuts to bring in woodpeckers.

In the spring we built a platform out of pallets for a hide which looked straight at the birds in our apple tree blossom.

Oliver often uses low and unusual angles, giving a different view to that of the casual observer, and out in the field he finds a tripod too restrictive, but he is happy to rest his camera on something to give him more steadiness when required – even if the 'something' is me, his father!

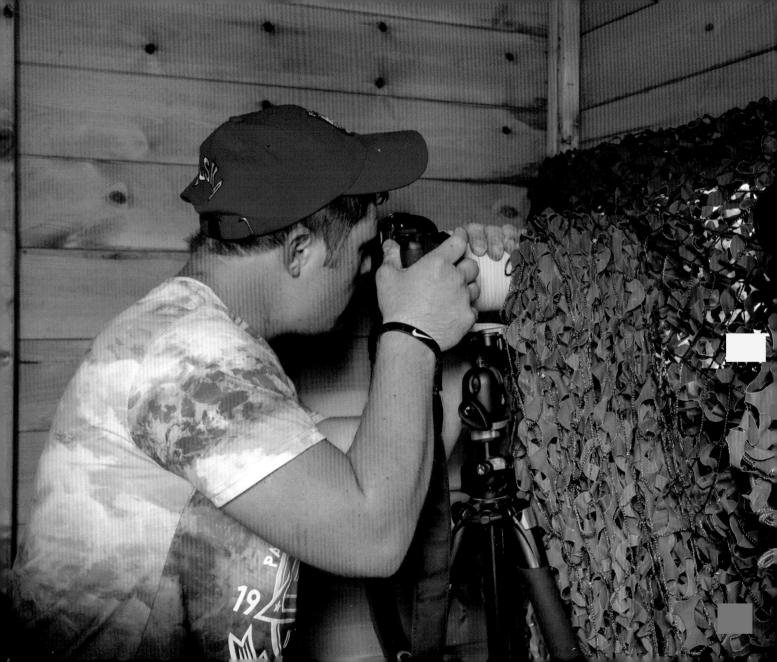

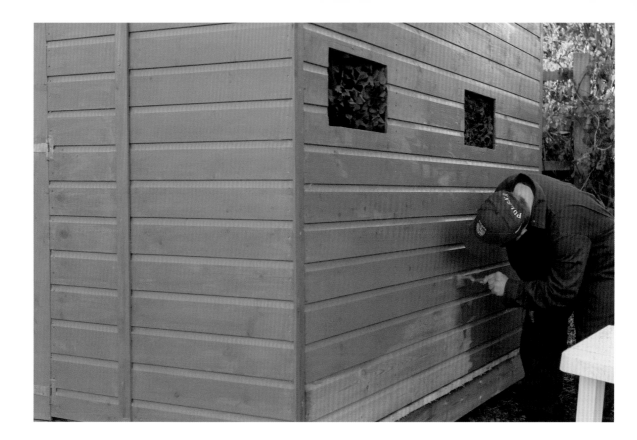

Blackdown Hills, Somerset

Inside our hide.

Painting the hide in our back garden.

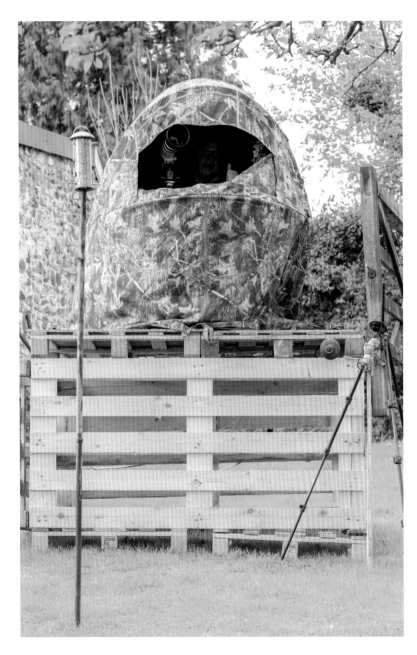

It's a hide on top of a pallet stand! We built it to get photos of the birds in our apple tree.

Reflection pool in the garden.

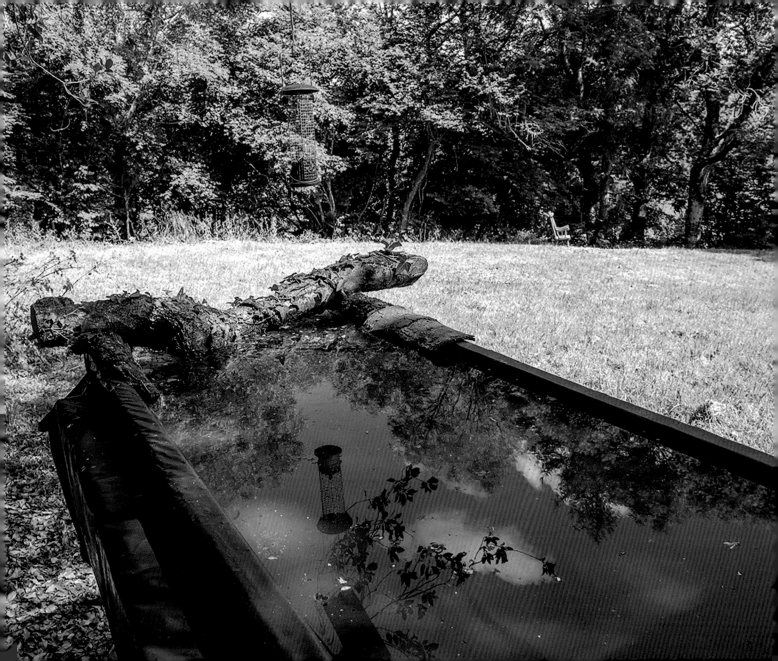

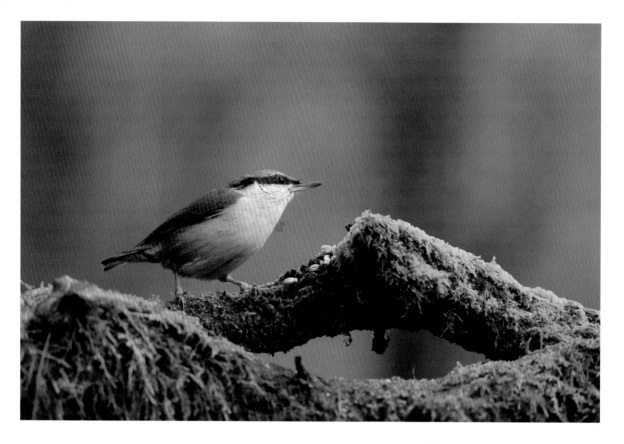

Above: Put some seeds into the mossy branches.

Right: Hang the birdfeeders by the pool.

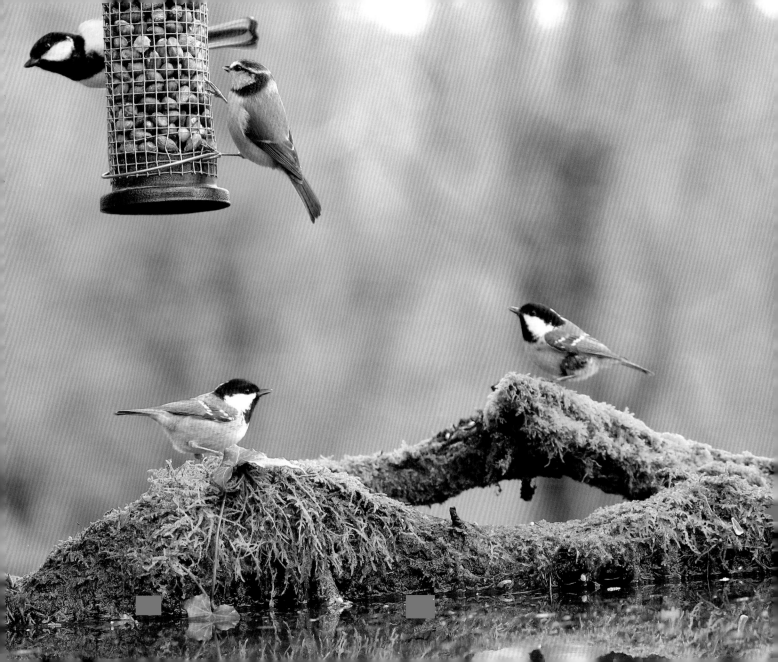

Slimbridge WWT

Catching unusual angles at Slimbridge.

Kilchurn Castle,
Loch Awe, Scotland

Using your father as a tripod.

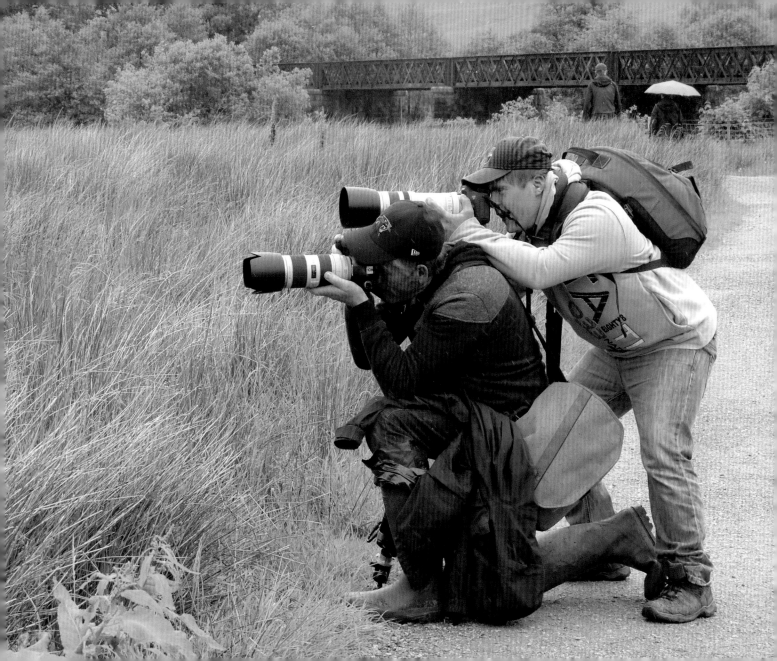

ISBN: 978 1 78884 010 1

British Library Cataloguing-in-Publication Data
A catalogue record for this book is available from the British Library

Front cover: 'Swan in the White Sea', Abbotsbury Swannery, Dorset.
Back cover: Oliver Hellowell

Printed in China
for ACC Art Books Ltd., Woodbridge, Suffolk, England

www.accartbooks.com

www.oliverhellowell.com
www.facebook.com/OliverHellowellPhotographer